IMAGES
of America

RIDGEWOOD

Acknowledgments

We would like to thank the many wonderful people who gave so generously of their time, whether to aid us in finding photographs for this project, or for trusting us with their treasured pictorials of Ridgewood's past. We especially extend our deepest appreciation to the following: Earl E. Alston, postmaster, Ridgewood Post Office; Belmar Spring Water Company; Rev. Judy Broecker, First Reformed Church; Catherine Enright, *Ridgewood News*; Catherine Epp; Victor E. Figlar, D.D.S.; Lt. Ronald Gimbert, Ridgewood Fire Department; Robert D. Griffin, historian; John Hawes; Rebecca Jimeniz and Marjory Levine, First Reformed Church; Peggy Norris, Ridgewood Library; Dorothy Pangburn, Ridgewood Historical Society; Marcy Siglar, Van Emburgh Funeral Home; Walter White, realtor; Larry Worth, village manager; and Barbara K. Carlton, Secretary, Ridgewood Historic Preservation Commission. Special thanks to Lawrence C. Hoffman, Ridgewood Historic Preservation Commission, who brought the project to our attention.

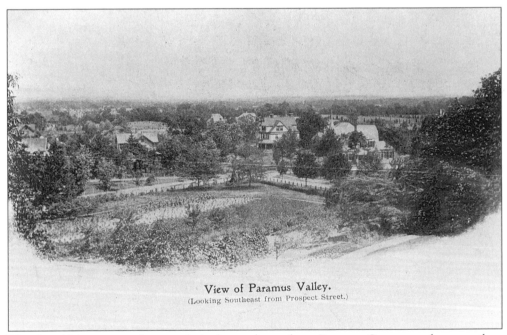

View of Paramus Valley.
(Looking Southeast from Prospect Street.)

This late-19th-century photograph looks southeast from Prospect Street at what was then called Paramus Valley, and reveals a far less developed area than today. Those residences eventually yielded to commerce. The dirt road (right center) is Union Street and the road (left center) that meets it is Dayton Street. Paramus Plains or Flats (the land situated between Van Dien Avenue and the Saddle River) is (right center) just above the building rooflines.

IMAGES
of America

RIDGEWOOD

Vincent Parrillo, Beth Parrillo,
and Arthur Wrubel

ARCADIA

Published by Arcadia Publishing,
an imprint of Tempus Publishing, Inc.
2 Cumberland Street
Charleston, SC 29401

Printed in Great Britain.

Library of Congress Catalog Card Number: Applied for.

For all general information contact Arcadia Publishing at:
Telephone 843-853-2070
Fax 843-853-0044
E-Mail arcadia@charleston.net

For customer service and orders:
Toll-Free 1-888-313-BOOK

Visit us on the internet at http://www.arcadiaimages.com

*We dedicate this book to the people of Ridgewood's
yesterdays who—each in their own way—helped create the
community legacy we enjoy today, and to those who seek to
preserve it for the tomorrows to come.*

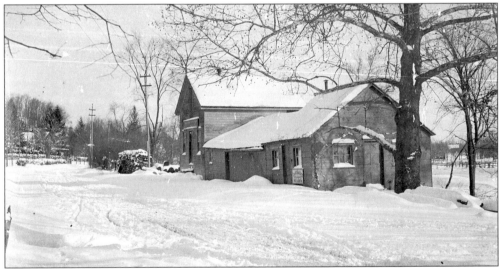

Abram J. Zabriskie built this sawmill in 1850 at the corner of North Maple Avenue and East
Glen Avenue, then erected an addition in 1870 for grinding grain. In 1902, Everett L. Zabriskie
had the building taken down so that the grounds would solely be part of his home residence.

CONTENTS

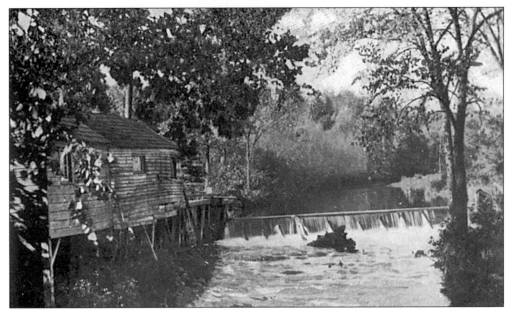

Several waterfalls in the Ho-Ho-Kus Brook supplied power to small, 19th-century gristmills along its bank. Shortly after 1800, one such mill was built near the corner of Maple and Glen Avenues. When it burned in 1853, it was rebuilt in the same year and leased to J.J. Zabriskie as a cotton mill, and it too burned in 1859. A third structure was built, and from 1879 to 1886, the Peerless Manufacturing Company made rubber products there.

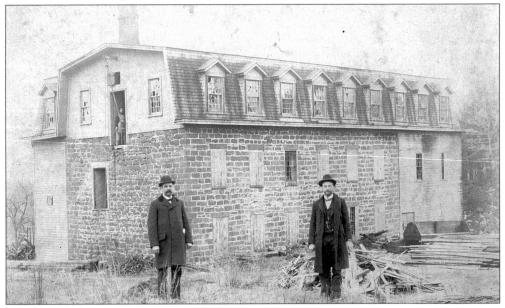

This mill, built in 1826, was part of Lydecker's Mills (Midland Park), but was closed and in disrepair in the 1890s when Henry Wostbrock (right, with an early partner named Helffenstein) reopened the mill. He was a wealthy man until the Depression, with a successful cotton embroidery business that sold its goods nationwide through its New York sales office. The third floor was destroyed in a 1975 fire, but the building still stands at Goffle Road and Paterson Avenue.

INTRODUCTION

The Village of Ridgewood lies in the foothills of the Watchung and the Ramapo Mountains of Northern New Jersey, about 22 miles northwest of New York City. In earlier years, much of the community was heavily wooded. That setting, together with the sudden rise to a 200-foot ridge west of the railroad tracks, with successive ridges reaching an elevation of 300 feet, particularly fits the name "Ridgewood." The southwestern section is less dramatic in elevation but remains, in large measure, a high plateau with heights reaching 250 feet before it drops suddenly to Goffle Brook, along Ridgewood's western boundary. The Ho-Ho-Kus Brook runs through the Village not far from its center, and farther, along its eastern boundary, flows a larger stream, which once gave to this part of the county the name Saddle River Valley.

Such an environment, according to numerous early-20th-century writers, resulted in a "remarkable diversity of scenery," a "varied picturesqueness," and a "great natural beauty of its rolling surface and wooded heights." "Nature seems to have outdone itself," said a *Ridgewood News* writer in 1919, "in making this area one of beauty and attractiveness." Indeed, for many years, Ridgewood was referred to as the "Garden Spot of New Jersey."

Drawing from a variety of sources, we chose photographs for this book that capture the community's evolution from a small Dutch and English settlement into a rural village popular with mid-19th-century summer vacationers from the city, and eventually, into an affluent suburban community within easy commuting distance to New York. The first three chapters thus flow chronologically: Early Ridgewood and the 18th-Century Stone Buildings (with an accompanying tour map), the Arrival of the Railroad, and Growth and Development. Chapter Four provides a view of some of the gracious old homes depicted in one or more historic publications, while Chapter Five depicts the architecturally important commercial buildings in the Historic Downtown District (with an accompanying tour map). Chapter Six illustrates many historical aspects of Ridgewood community life in athletic, civil service, education, religious, and social settings. Chapter Seven offers a pictorial reminder of some of the wonderful structures that have been lost to future generations because of "progress." Throughout the book, the captions provide insight and slice-of-life commentaries that further augment the reader's knowledge about the Village of Ridgewood.

Through careful research we have attempted to provide an accurate presentation of Ridgewood's past, and we accept responsibility for the historical veracity of this book. Both Vince Parrillo and Art Wrubel are members of the Ridgewood Historic Preservation Commission, the latter serving as its chair.

One

EARLY RIDGEWOOD

AND THE 18TH-CENTURY STONE BUILDINGS

Built in the late 18th and early 19th centuries, the nine stone houses of Ridgewood, together with the Paramus Reformed Church and Schoolhouse, were constructed on the oldest roads in the community, some of them old Native American trails: East Ridgewood Avenue, Ackerman Avenue, Glen Avenue (formerly Libby Lane and Harrison Street), Lincoln Avenue (formerly Cherry Lane), Paramus Road, and Maple Avenue.

These small homes were built from local brown sandstone. These building blocks, about 8 inches in height, were laid in a binding material of clay from the fields, mixed with straw. While the straw has given way to mortar, the distinctive stone walls have remained through the centuries. The typical house measured 19 feet square and was organized vertically, with a single main room where family activities took place (with a fireplace on the side), a sleeping loft above with access by a ladder, and a food storage level in the basement. Wings and dormers were added as each family prospered and grew. The houses faced southeast to use the sun to warm and light the interior. In the early 19th century, when prefabricated cast iron stoves were used for cooking and heating, the houses then began facing the road.

This tour is about 7 miles from start to finish. Begin at the home listed as number one on the accompanying map and travel in a great semi-circle through history. All 11 structures are on the State and National Registers of Historic Places.

STONE HOUSES
OF
RIDGEWOOD

Above is a half-page Stone House Map.

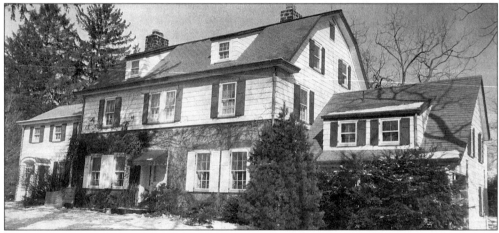

This photograph of the Van Dien House (#1 on the map), 627 Grove Street, was built c. 1736–1770. Garret Van Dien—whose farming family moved from the Flatbush section of Brooklyn in 1675—bought a 552-acre tract of land in the southern section of the Ramapo Patent in 1713. In 1736, he built a small kitchen and room above. Generations of Van Diens occupied the house until 1900. Interior doors and hardware are over 200 years old, and the beams in the kitchen are original to the house.

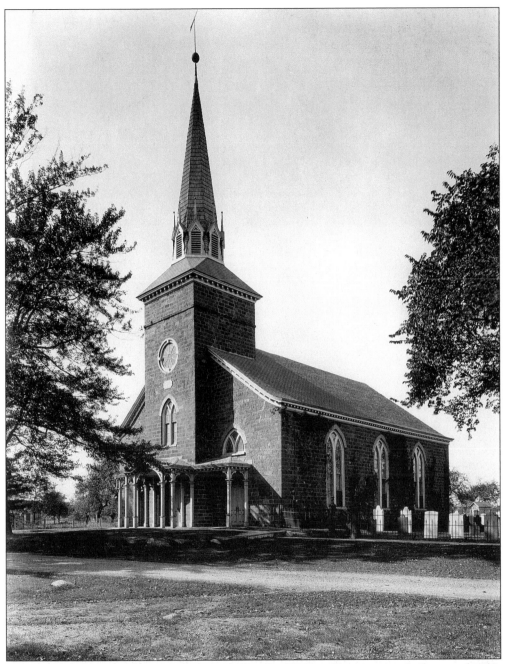

Number 3 on the map is Paramus Reformed Church, 660 East Glen Avenue, built around 1800. Built on the site of the 1735 church from its stones and materials, this is a fine example of early Bergen County, neo-Gothic stone church architecture. The first church, used by both sides during the Revolution, was a barracks, hospital, prison, and burying ground. Washington wrote 27 letters from here, and at least one bears the heading "Pyramus Church." He also attended here the court-martial of Gen. Charles Lee (July 11–15, 1778), at which Col. Alexander Hamilton testified. Others here then were Gen. Richard Henry Lee, Gen. Anthony Wayne, Col. Aaron Burr, and the Marquis de Lafayette.

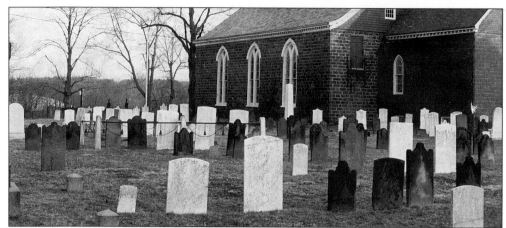

This cemetery, adjacent to the Paramus Church, is the oldest in the area and was in use from *c.* 1735 to *c.* 1852. The graves of early settlers, marked by crude stones, are here, as are those of many Revolutionary soldiers from both sides, including Capt. John Hooper, a Bergen County militia officer. Also buried here are the victims of a British raid on the church area in March 1780.

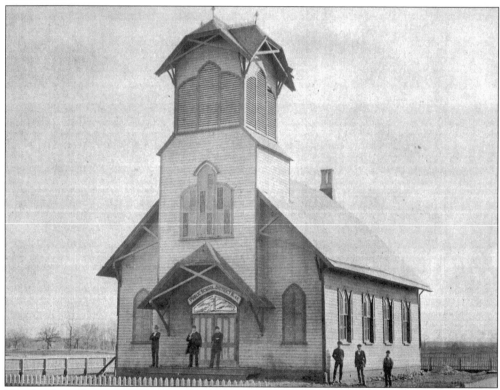

Number 2 on the map is the schoolhouse at 650 East Glen Avenue, built in 1872. Four other schools previously stood on this site, next to the Paramus Reformed Church, which, from 1730 to 1870, assumed responsibility for its operations. This structure was rented to Ridgewood Township from the 1870s to 1905, when it was known as District School 45. The wood frame and clapboard school, shown here with its square belfry intact, has a sandstone foundation, a large attic, and gothic windows.

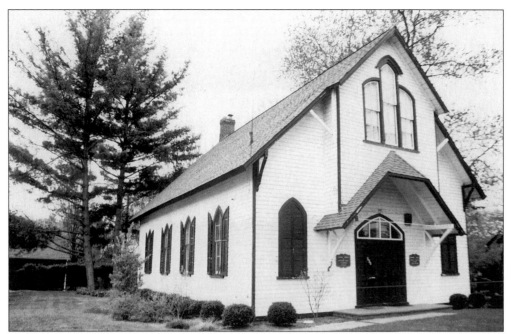

Pictured again is the 1872 schoolhouse at 650 East Glen Avenue, with its cumbersome, square belfry removed. This structure, Ridgewood's last remaining one-room schoolhouse, was built at a cost of $4,600. When the Kenilworth School was built in 1905, this school fell into disuse. Since April 23, 1955, it has been used as a museum. Besides exhibits of various artifacts of a bygone era, the museum contains a small but excellent historical library in the back of the building.

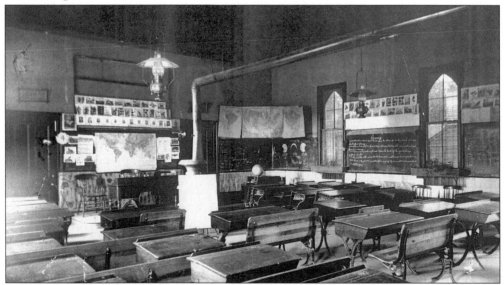

The interior of what is now known as the Schoolhouse Museum, contains many artifacts of the period, and the building is now home to the Ridgewood Historical Society. The high-ceiling classroom was heated by a centrally located, large global stove. A wing in the rear contained the original restrooms. The room's original wainscoting remains on the plaster walls. Much of the school equipment remains, and, except for the belfry, the building is basically unaltered.

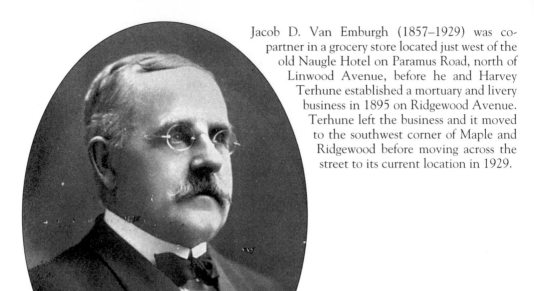

Jacob D. Van Emburgh (1857–1929) was co-partner in a grocery store located just west of the old Naugle Hotel on Paramus Road, north of Linwood Avenue, before he and Harvey Terhune established a mortuary and livery business in 1895 on Ridgewood Avenue. Terhune left the business and it moved to the southwest corner of Maple and Ridgewood before moving across the street to its current location in 1929.

The Ackerman-Van Embergh House (#4 on the map) was built at 789 East Glen Avenue in 1785–87. Built by John Ackerman, then sold to J.D. Van Embergh in 1816, this is actually two houses in one, with a frame addition from the 18th century. Known as the "Maple Homestead," with 200 acres of farmland spreading northward, its exterior is unchanged except for the addition of dormers. Its setting, however, has been greatly altered by the widening of East Glen Avenue and East Saddle River Road.

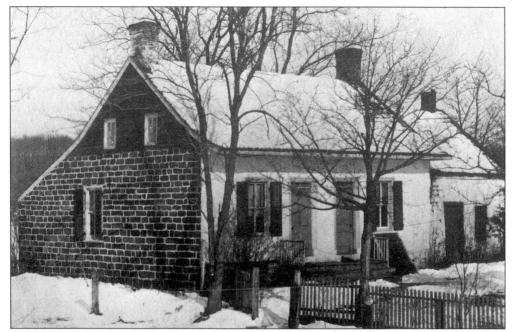

The David Ackerman House (#5 on the map), 415 East Saddle River Road, was built c. 1750–60. Possibly the oldest house in Ridgewood, shown here in an 1871 photograph, the Ackerman residence may have been built by David's son Garret. David Ackerman settled here on 200 acres of the New Paramus Patent in 1732. Originally a one-room colonial farmhouse, it later became the kitchen when a new main room and small bedroom were built alongside.

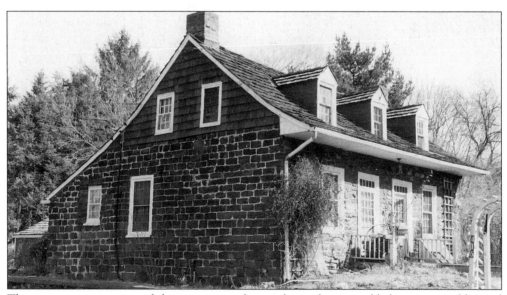

This contemporary view of the same stone house shows dormers added to create additional living space, but both the exterior and interior remain characteristic of Dutch Colonial homes. The house, part of a settlement on the east bank of the Saddle River, retains its original mantle, beams, and floorboards. Its ceiling height of 7 feet 3 inches to 7 feet 10 inches and first-floor wall thickness of 20 inches were typical dimensions of that era.

15

The Rathbone-Zabriskie House (#6 on the map) was built at 570 North Maple Avenue *c.* 1790. This house, located on one of the earliest roads in the area, stands within the northern boundary of the Isaac Kingland Patent of May 12, 1687, which contained 500 acres. This area became known as Hoppertown prior to the Revolution, due to the abundance of Hopper families living there. This may have been one of the Hopper homes.

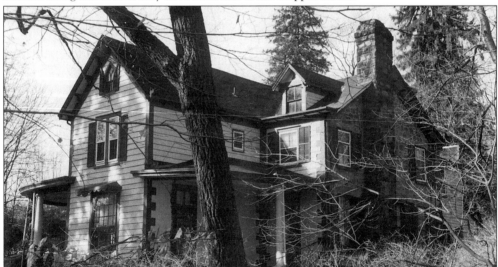

The Westervelt-Cameron House (#7 on the map) was built at 26 East Glen Avenue in 1767. A stone house that evolved into a mansion, it is located on the Kingland tract. Probably a small sandstone structure typical of that time, it was bought by Alexander Cameron in 1859 and enlarged into a Victorian mansion. The original stone walls reached the peaks of the two-story extension and the frame wings were added. The first-floor ceiling height is 9 feet and the walls are 22-inches thick.

The Archibald Vroom House (#8 on the map) is located at 162 East Ridgewood Avenue. Built in 1789 by John M. Archibald on a 26-acre farm, its next owner was Peter Hopper, who opened the first store here in 1830. Changes made to the structure in the 1880s include its vernacular Gothic Revival modifications, most notably the rakeboards. The building retains its original stone wall and roof shape; the dormers were added later. Dr. William Vroom bought the house, set up his practice, and added a large wing for a hospital.

The Vanderbeck House (#9 on the map) was built at 249 Prospect Street, c. 1790. Harmanus and Abraham Vanderbeck lived in this area. This charming house still has its original, small-paned windows, with twelve in the upper section and eight below, and a double-leaf door with a three-light transom. Placed on a triangular lot where two main streets come together, this house may have been close to a tollgate and was perhaps even used as a tollhouse.

The Ackerman House (#10 on the map) was built at 222 Doremus Avenue, *c.* 1787. Johannes and Jemina Ackerman farmed their 72.6 acres from this farmhouse. The Ackerman family occupied the house until 1927. Although greatly altered (its floor in the main unit has been lowered, facade stuccoed, windows and doors reset, and fireplace rebuilt, with no evidence of its original location), it still retains enough of its original fabric to be listed on the National Register of Historic Places.

The Ackerman House (#11 on the map) was built at 252 Lincoln Avenue, *c.* 1810. John or David Ackerman is believed to have been associated with this property, which is now significantly altered. A stone house now covered with stucco, its gambrel roof shape was typical of larger stone houses in the 18th century, when farmhouses expanded to reflect the prosperity of the owner. The interior of the stone section is now one large room.

Two

THE ARRIVAL OF
THE RAILROAD

After completion of the Paterson and Ramapo Railroad in 1848, only 20 families lived in Godwinville, and the single-track railroad had a station in Undercliff (Ho-Ho-Kus). Manufacturers in Wortendyke (Midland Park), clustered along Goffle Brook, pressured the railroad for a closer station to remain competitive with factories along Ho-Ho-Kus Brook. They got a freight stop in 1851, and residents built their own station in 1859. Then, increased commercial and passenger activity created a demand for businesses and homes, and the population grew from 59 homes in 1851 to 1,200 homes by 1876, with land selling for $200-$500 an acre. The railroad added a second track in 1865, and two more in 1902–03.

Strawberries were an important crop. During the last week of June 1858, for example, 1,100 wagon loads carried 1.5 million pints to market through the Bergen Turnpike tollgates. Such farm prosperity brought demands for improved turnpikes, but railroads supplied the greater speed. Strawberries thus helped link the Paterson and Ramapo Railroad north from Paterson to the Erie Railroad in Suffern. When strawberries were in season, the railroad took as many as eight boxcars full out of Allendale and Ramsey every morning.

Meanwhile, some New York doctors recommended Godwinville for its healthful, malaria-free climate, making it a popular summer resort by the 1850s. Some New Yorkers stayed, including Cornelia Dayton who, like others, found the tree-lined ridges and acres of forestland an impressive sight. She successfully campaigned to change Godwinville to Ridgewood; the post office agreed in 1865, and the railroad a year later.

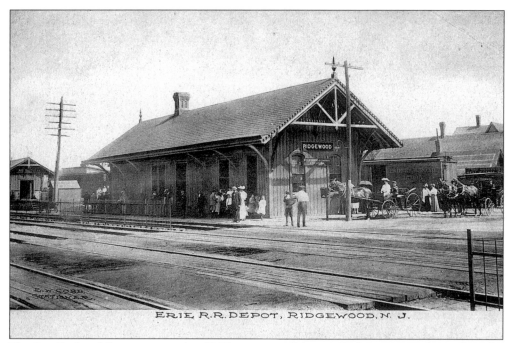

ERIE R.R. DEPOT, RIDGEWOOD, N. J.

The Erie Railroad Depot, pictured *c.* 1905, was a wood-frame, Gothic structure located on the northbound or Suffern side of the tracks. It had a passenger waiting room, ticket area, and storage room. Its narrower south side, where horse-drawn carriages parked, faced East Ridgewood Avenue. The waiting carriages suggest many of those pictured may be awaiting the arrival of friends and relatives.

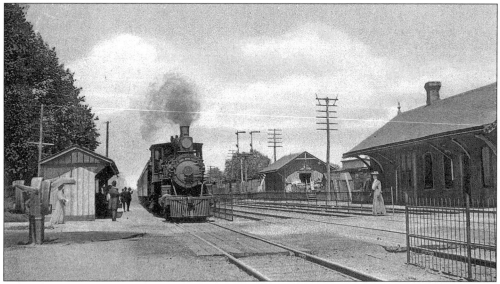

A Hoboken-bound train is shown arriving in Ridgewood in 1907. On this southbound side of the tracks, a small passenger shelter offers protection from sun or precipitation and the station itself is visible on the right. At the far left is a lowered crossing gate, stopping vehicular traffic across the Ridgewood Avenue grade crossing, which served as the major east-west thoroughfare at that time.

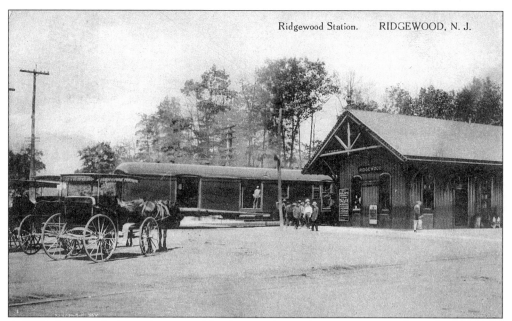

A 1912 photograph shows the taxis of the day, two horse-drawn surreys—with, as the song goes, "a fringe on the top"—waiting at the old Ridgewood train station for arriving passengers, who would need transportation to somewhere in the village. A stopped baggage car, the last car on this northbound train, has for some reason attracted a group of men.

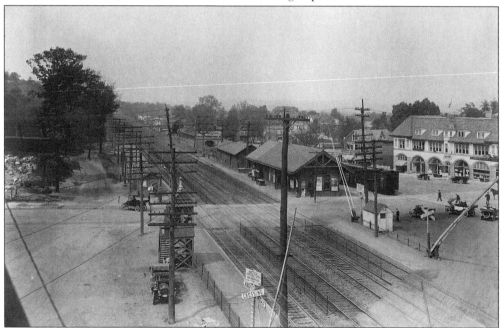

This photograph, taken *c.* 1914, before construction of the railroad overpass on Franklin Avenue, shows the dual railroad crossing gates at East Ridgewood Avenue and at Godwin Avenue. Railroad siding tracks are behind the station along North Broad Street. On the left is a railroad watchtower and on the right is a gateman, standing by the small gatehouse. The just completed Wilsey Building shows workmen putting finishing touches on the second floor.

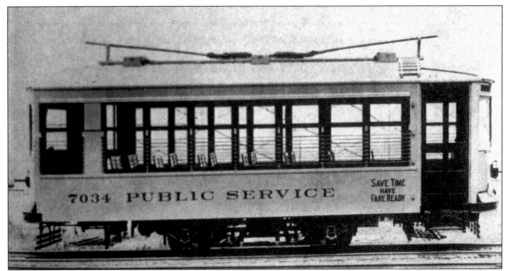

The importance of the railroad station prompted a trolley line connecting it with industrial Paterson. The line, completed in 1914, ran until 1925 and stopped behind what is now Davis Surgical Store. It proceeded along Washington Place to Clinton Street, turning south along Highland Avenue and then along Goffle Road to Paterson. The fare was 10¢ and the travel time was 36 minutes.

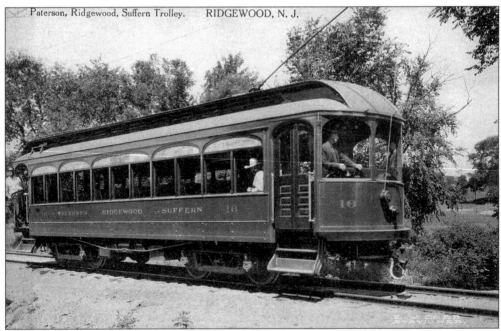

The North Jersey Rapid Transit Company, which eventually became part of the Public Service system, ran a trolley line (1910–1929) from Paterson through Ridgewood to Suffern. Its demise, part of a national trend, occurred when competing bus lines using tax-supported highways siphoned away riders from the tax-paying trolley companies. The trolley's right of way still exists through Ridgewood and is now occupied by Public Service gas and electric lines.

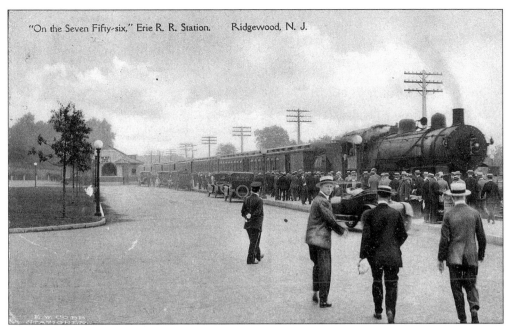

This 1918 photograph shows the new train station in the background, as commuters going to work in New York City prepare to get "on the Seven Fifty-six," as the photographer labeled this shot. Almost all of the men are wearing "boaters," straw hats that were a normal part of male attire in the warm weather. The eight-car train suggests the extensive commuter traffic of that era.

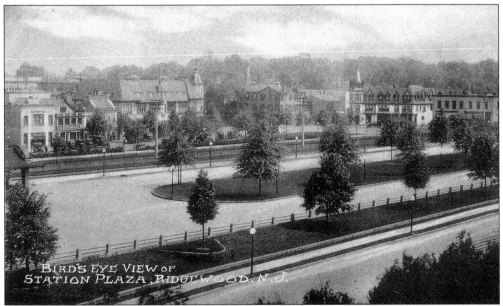

BIRD'S EYE VIEW OF STATION PLAZA, RIDGEWOOD, N. J.

This view looking eastward from the Heights section (c. 1916) reveals the "new look" of the village. The newly completed station plaza, temporarily devoid of automobiles, had a wider center island then. Looking from left to right, one can see the roof edge of the station, the Dwyer Building, Wilsey Building, Ryerson Building, and Moore Building. By this time, the Ridgewood Avenue grade crossing had been eliminated.

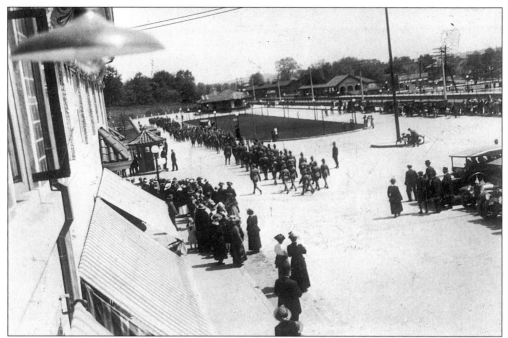

Passenger trains served not just commuters and vacationers. This 1918 photograph, taken from the second floor of the Play House, shows soldiers from the area marching through Wilsey and Garber Squares to the railroad station. From there, they would board a train on the first leg of their journey overseas to fight on the European battlefields of World War I. Some would never return. They are remembered at the War Memorial in Van Neste Square.

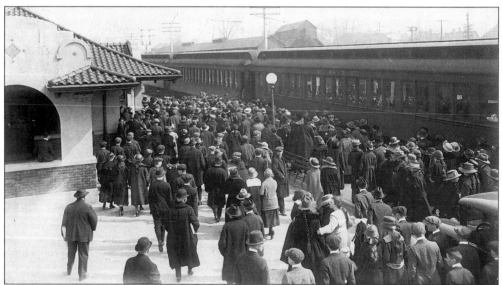

A large crowd of commuters, perhaps on their way to a special event, prepare to board the southbound train. By the 1920s Ridgewood emerged as a commuter suburb, with many of its residents commuting to New York to work for major banks and corporations. These passenger cars were in use until the 1970s, when New Jersey Transit took over the railroad from the Erie. The Young and Bortic coal yard looms in the background.

24

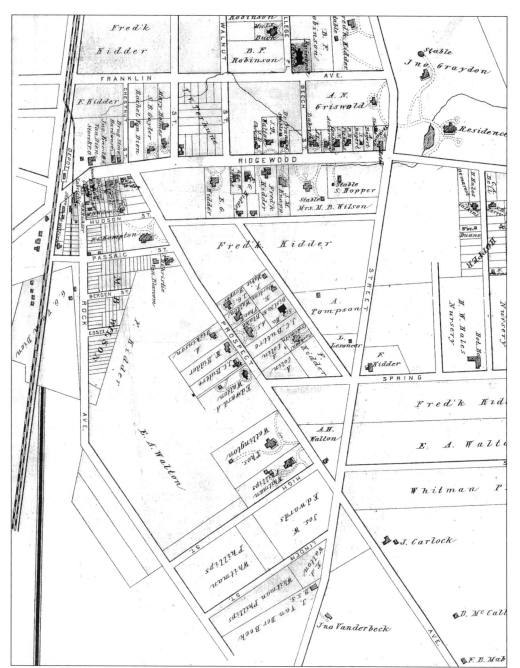

The *Walker Atlas* of 1876 was the first detailed map of downtown Ridgewood and indicated the main streets radiating from the railroad station. The depot (upper left) faces East Ridgewood Avenue, along which commercial development had only extended to Prospect Street (right), with the Ridgewood Hotel indicated at mid-block. Commercial enterprises (left) extend about the same distance to Chestnut Street.

TABLE 1

CONDENSED TABLE OF THROUGH TRAINS
NEW YORK AND BUFFALO, CLEVELAND AND CHICAGO
(FOR LOCAL TRAINS AND INTERMEDIATE TIME OF THROUGH TRAINS SEE LOCAL TABLES)

Air-Conditioned Trains—Air-conditioned equipment has been assigned to regular sections of trains as shown herein. Every effort will be made to provide it as specified, but the right is reserved to employ non-air-conditioned cars as necessitated by volume of traffic or emergencies.

WESTBOUND		EASTBOUND	

WESTBOUND

THE ERIE LIMITED — TRAIN NO. 1—DAILY
New York—Buffalo—Jamestown—Chicago

Lv New York, W. 23d St...... ef 8.35AM E.S.T.	
" Jersey City.................. 8.40 "	
" Paterson.................en 9.27 "	**EQUIPMENT**
" Ridgewood...............en 9.37 "	Air-Conditioned Sleeping Cars:
" Binghamton............... 2.25PM "	New York to Chicago—8 Section Lounge
" Elmira.................... 3.44 "	Restaurant Car.
Ar Buffalo (Lehigh Valley Term.) 7.35 "	Hornell to Chicago—8 Section, 1 Compart-
Lv Olean.................... 6.45 "	ment Lounge Restaurant Car.
" Bradford..............ad 6.42 "	
" Buffalo (Lehigh Valley Term.) 5.30 "	Air-Conditioned Salon Coaches:
" Jamestown................ 8.03 "	New York to Chicago.
" Meadville................. 9.40 "	
" Youngstown.............. 11.16 "	Air-Conditioned Coach—Diner:
" Warren................... 11.42 "	New York to Buffalo.
Ar Chicago (Dearborn Sta.).... 12.50AM C.S.T.	Additional Dining Service for all meals in Air-Conditioned Lounge Restaurant Cars.

THE LAKE CITIES — TRAIN NO. 5—DAILY
New York—Buffalo—Cleveland

Lv New York, W. 23d St...... 7.10PM E.S.T.	**EQUIPMENT**
" Chambers St..... 7.40 "	Air-Conditioned Sleeping Cars:
" Jersey City.............. 8.00 "	New York to Cleveland—10 Section, 2
" Paterson................. 8.29 "	Compartment and Drawing-room.
" Ridgewood............... 8.39 "	New York to Bradford—12 Section and
Ar Buffalo (Lehigh Valley Term.) 7.05AM	Drawing Room.
Lv " 5.56 "	(Sleeping Car may be occupied at Bradford until 8.00 A. M.)
Ar Bradford................. 7.20 "	Air-Conditioned Lounge Dining Car:
" Jamestown.............. 7.21 "	New York to Port Jervis.
" Meadville............... 8.52 "	Salamanca to Youngstown.
" Youngstown............. 10.11 "	Air-Conditioned Coaches:
" Warren................. 10.44 "	New York to Cleveland.
Ar Cleveland.............. 11.50AM	Coaches: Hornell to Buffalo.

THE MIDLANDER — TRAIN NO. 15—DAILY
New York—Jamestown—Akron—Chicago

Lv New York, W. 23d St...... 7.10PM E.S.T.	**EQUIPMENT**
" Chambers St..... 7.40PM	Effective from New York June 2
" Jersey City.............. 8.00PM	Air-Conditioned Sleeping Car:
" Paterson..............bc 8.29PM	New York to Chicago—10 Section, 2 Compartment and Drawing-room.
" Ridgewood............bc 8.39PM	Air-Conditioned Lounge Dining Cars:
" Jamestown.............. 7.07AM	New York to Port Jervis.
" Meadville.............. 8.28AM	Hornell to Chicago.
" Youngstown............ 9.48AM	Air-Conditioned Coach:
" Akron................. 11.08AM	New York to Chicago.
" Marion................ 1.13PM	
Ar Chicago (Dearborn Sta.)... 5.20PM C.S.T.	

PACIFIC EXPRESS — TRAIN NO. 7—DAILY
New York—Buffalo—Jamestown—Chicago

Lv New York, W. 23d St...... 10.55PM E.S.T.	
" Chambers St....11.30 "	**EQUIPMENT**
" Jersey City.............12.05AM	
" Elmira................ 7.29 "	Air-Conditioned Sleeping Car:
Ar Buffalo (Lehigh Valley Term.)11.55AM	New York to Salamanca—12 Section and
Lv Olean................ 11.07AM	Drawing-room Car.
Ar Salamanca............ 11.29 "	(Sleeper open Jersey City at 9.30 P. M.)
Lv Jamestown............ 12.24PM	
" Youngstown........... 2.01 "	Air-Conditioned Dining Lounge Car:
" Warren............... 3.34 "	Binghamton to Hornell.
" Akron................ 4.01 "	
Ar Chicago (Dearborn Sta.).... 5.05 "	Air-Conditioned Salon Coaches:
	New York to Chicago.
	1.00AM C.S.T.

TRAIN NO. 9—DAILY
New York—Binghamton

Lv New York, W. 23d St...... 7.30AM E.S.T.	
" Chambers St.....8.00 "	**EQUIPMENT**
" Jersey City............. 8.15 "	
" Paterson.............bb 8.42 "	Through Coaches....New York to Binghamton.
" Ridgewood...........ap 8.51 "	
Ar Binghamton........... 2.35PM	

THE MOUNTAIN EXPRESS — TRAIN NO. 27—DAILY
New York—Binghamton—Elmira—Hornell

Lv New York, W. 23d St...... 2.20 PM E.S.T.	**EQUIPMENT**
" Jersey City............. 2.55 "	
Ar Binghamton........... 8.45 "	Air-Conditioned Dining Lounge Car:
" Elmira............... 10.35 "	New York to Binghamton.
" Corning............. 11.02 "	Through Coaches....New York to Hornell.
Ar Hornell............. 12.05 AM	

EASTBOUND

THE ERIE LIMITED — TRAIN NO. 2—DAILY
Chicago—Jamestown—Buffalo—New York

Lv Chicago (Dearborn Sta.).... 6.00PM C.S.T.	
Ar Akron.................. 3.44AM E.S.T.	
" Warren................. 4.43 "	**EQUIPMENT**
" Youngstown............ 5.02 "	Air-Conditioned Sleeping Car:
" Meadville.............. 6.55 "	Chicago to New York—8 Section Lounge
" Jamestown............. 8.31 "	Restaurant Car.
" Buffalo (Lehigh Valley Term.).10 55 "	
" Bradford...........ad 12.05PM	Air-Conditioned Salon Coaches:
" Olean................. 9.30AM	Chicago to New York.
Lv Buffalo (Lehigh Valley Term.) 8.20 "	
Ar Elmira................ 12.30PM	Air-Conditioned Coach—Diner:
" Binghamton........... 1.43 "	Buffalo to New York.
" Ridgewood.........ek 6.43 "	
" Paterson............ ♦ 6.52 "	Additional Dining Service for all meals in Air-Conditioned Lounge Restaurant Car.
" Jersey City........... 7.20 "	
" New York, Chambers St..... 7.34 "	
" " W. 23d St...... 7.55PM	

THE LAKE CITIES — TRAIN NO. 6—DAILY
Cleveland—Buffalo—New York

Lv Cleveland............... 4.00ᴾ E.S.T.	
" Warren................. 5.08 "	**EQUIPMENT**
" Youngstown............ 5.38 "	Air-Conditioned Sleeping Cars:
" Meadville.............. 7.19 "	Cleveland to New York—10 Section, 2
" Jamestown............. 8.59 "	Compartment and Drawing-room.
" Bradford.............. 8.55 "	Bradford to New York—12 Section and
" Salamanca............ 10.01 "	Drawing Room.
" Olean................ 10.26 "	
" Buffalo (Lehigh Valley Term.) 9.00 "	Air-Conditioned Lounge Dining Car:
Ar Elmira............... 1.16AM	Youngstown to Salamanca.
" Ridgewood.........dz 7.10 "	Port Jervis to New York.
" Jersey City........... 7.40 "	Air-Conditioned Coaches:
" New York, Chambers St..... 7.54 "	Cleveland to New York.
" " W. 23d St...... 8.05AM	Coaches: Buffalo to Hornell.

THE MIDLANDER — TRAIN NO. 16—DAILY
Chicago—Akron—Jamestown—New York

Lv Chicago (Dearborn Sta.).... 9.05AM C.S.T.	**EQUIPMENT**
" Marion................ 3.10PM E.S.T.	Effective from Chicago June 3
" Akron................. 5.15PM	Air-Conditioned Sleeping Car:
" Youngstown............ 6.31PM	Chicago to New York—10 Section, 2 Compartment and Drawing Room.
" Meadville............. 7.56PM	Air-Conditioned Lounge Dining Cars:
" Jamestown............ 9.13PM	Chicago to Hornell.
" Ridgewood..........dz 7.10AM	Port Jervis to New York.
Ar Jersey City........... 7.40AM	Air-Conditioned Coach:
" New York, Chambers St... 7.54AM	Chicago to New York.
" " W. 23d St..... 8.05AM	

ATLANTIC EXPRESS — TRAIN NO. 8—DAILY
Chicago—Jamestown—New York

Lv Chicago (Dearborn Sta.)......10.00PM C.S.T.	
" Akron................. 7.22AM E.S.T.	**EQUIPMENT**
" Warren................ 8.22 "	Air-Conditioned Sleeping Cars:
" Youngstown............ 8.50 "	Chicago to Hornell—8 Section, 1 Compartment Lounge Restaurant Car.
" Meadville............. 10.25 "	(Sleeper open at Chicago at 9.30 P. M.)
" Jamestown............ 12.15PM	Air-Conditioned Salon Coaches:
" Bradford............. 10.02AM	Chicago to New York.
" Salamanca............ 1.18PM	Air-Conditioned Dining Lounge Car:
" Olean................ 1.44 "	Hornell to New York.
Ar Elmira.............. 6.11 "	(No baggage handled on this train east of Hornell; baggage will be handled on following train.)
" Binghamton.......... 6.23 "	
" Jersey City.......... 11.45 "	
" New York, Chambers St..... 11.67PM	
" " W. 23d St......	

SOUTHERN TIER EXPRESS — TRAIN NO. 10—EX. SUN.
Buffalo—Hornell—Elmira—Binghamton—New York

Lv Buffalo............... 4.35PM E.S.T.	
" Hornell............... 7.30 "	**EQUIPMENT**
" Corning.............. 8.40 "	Air-Conditioned Sleeping Car:
" Elmira............... 9.10 "	Hornell to New York—12 Section and Drawing-room Car.
" Binghamton.......... 10.41 "	(Sleeper and Coaches may be occupied at Jersey City until 7.00 A. M. E.S.T.)
Ar Jersey City.......... 4.15AM	Coaches:—Buffalo to Hornell.
" New York, Chambers St..... 4.27AM	Hornell to New York.
" " W. 23d St......	

THE MOUNTAIN EXPRESS — TRAIN NO. 28—DAILY
Binghamton—New York

Lv Binghamton.......... 10.15AM E.S.T.	
Ar Ridgewood........... 5.02PM	**EQUIPMENT**
" Paterson............ 5.11 "	
" Jersey City.......... 5.40 "	Through Coaches...Binghamton to New York.
" New York, Chambers St... 5.54 "	
" " W. 23d St..... 6.06PM	

For Explanation of Reference Marks and Notes, See Pages 5 and 6.

This 1939 railroad timetable promoting the New York World's Fair also offers glimpses into the transit possibilities of the 1930s, a time when traveling by train was far more common than by airplane. Without the hassle of traveling to and from airports, it was then possible to travel from the Ridgewood station to the centers of Akron, Binghamton, Buffalo, Chicago, Cleveland, and Jamestown.

Three

GROWTH AND DEVELOPMENT

The flyleaf of an 1898 publication, *Picturesque Ridgewood*, explained that it was "An illustrated brochure showing the principal residences, the public buildings, churches, street scenes and scenes along the Ho-Ho-Kus Brook and Saddle River." It depicts the main thoroughfares as dirt roads without sidewalks, shaded with big trees and dense foliage, and sometimes bordered by old-fashioned, wooden-rail fences, with few houses visible from the roadway.

All would soon change. By 1900, Ridgewood became an alternative to New York City life as the population reached 2,685 and the frequency of train service put the area within commuting distance. A 1902 promotional article urged New Yorkers to "look north-westward to the beautiful calm of the Paramus Valley" with its "endless chain of grandeur" where "you will find an ideal spot for a cosy, comfortable home." Moreover, it continued, Ridgewood was home to "a very large percentage of Brooklyn residents, many of whom can testify that they have been greatly benefited in health since breathing the dry and pure air of Paramus Valley."

As New York doctors recommended Ridgewood to patients with lung problems, summer vacationers became permanent residents, and New Jerseyans discovered the village as a desirable place to live, its residential area and commercial center expanded. Development spread into adjacent residential areas, which were within walking distance of the railroad station. Wastena Park, Ridgewood Heights, Woodside Park, Prospect Park, and Brookside became popular residential neighborhoods. By 1930 the downtown business district boundaries still seen today were evident. A few residences remained on West Ridgewood Avenue, between Maple and Cottage Place and on Franklin Avenue, but they eventually disappeared as the commercial district expanded.

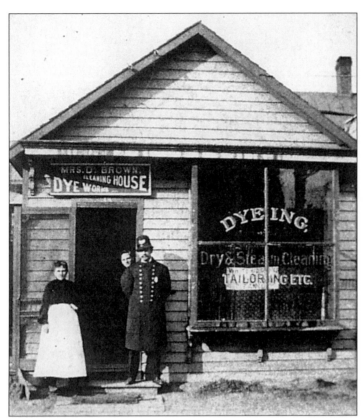

Mrs. D. Brown's Cleaning House and Dye Works, which offered both dry and steam cleaning, was located near the Moore Building. Standing next to her is James Houlihan, one of Ridgewood's three police officers in 1897. A hand-lettered sign in the store window announces that ladies may leave their white kid gloves for cleaning. Note the wooden sidewalk and plank leading into the street.

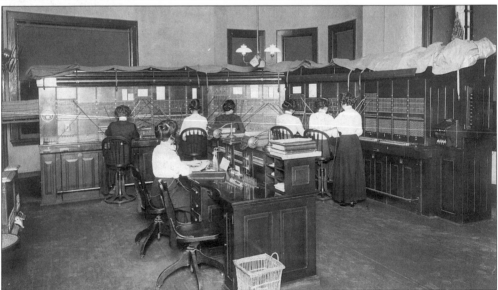

As the village edged closer to a new century, one sign of a changing lifestyle was the growing popularity of the telephone. Tice's Drug Store, at East Ridgewood Avenue and Chestnut Street, housed facilities for Ridgewood's telephone service in 1896, when this photograph was taken. The store burned down in 1900, along with the ten-position, 100-line switchboard, causing a major disruption of service.

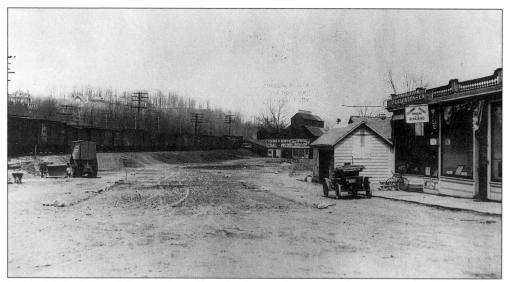

In 1912, North Broad Street (shown here looking north from Ridgewood Avenue) had limited development along its dirt road. Below the Heights section (left) is a freight train rumbling through town. At the end of the street, where no road to the left then existed, is Young & Bortic Coal and Wood Company (founded in 1886), where Ken Smith Motors now stands. Today the old coal storage bins adjacent to the railroad tracks serve as the dealer's parking area.

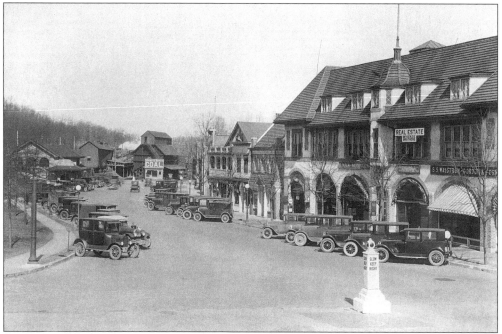

By 1924, the same scene was far more developed and gentrified. Now paved—with sidewalks, curbing, street lamps, and more elaborate structures along its edges—the street held dozens of cars facing outward in angle parking. Although this picture shows little traffic, apparently enough existed to warrant the warning divider in the foreground. At the left rear is the eight-year-old railroad station and on the right is a partial view of the then ten-year-old Wilsey Building.

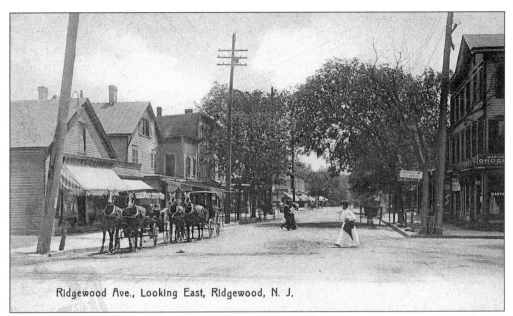

Ridgewood Ave., Looking East, Ridgewood, N. J.

An unpaved East Ridgewood Avenue (looking east from North Broad Street, *c.* 1900) had years earlier established itself as the main commercial street, partly because it was a major east-west artery from Paramus to Midland Park. Next to Martin's grocery store in the Ryerson Building (right), is the office of the *Ridgewood Herald*, which began as a staunch Republican newspaper as counterpoint to the Democratic *Ridgewood News*. In 1941, the two papers merged and became the *Herald News*. In 1914, the Wilsey Building replaced the buildings on the left.

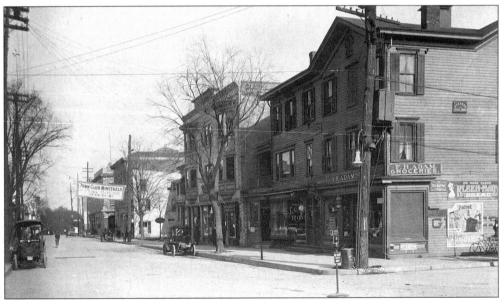

The same view (*c.* 1915) showed East Ridgewood Avenue accommodating bicycles and horse-drawn and horseless carriages. F.H. Adams ran the grocery store next to the Lunch Room. The new neighbor, the Hopper Building (second building from right), had cigar and real estate establishments. At the First National Bank, just before the Ridgewood Trust Company, a banner advertises the Town Club Minstrels performances at the Play House on Garber Square.

This westward view of Ridgewood Avenue (*c.* 1908) shows sidewalks and curbing installed, but the street still dirt. The original First National Bank Building (left) at the corner of Prospect Street is opposite the Hennion Building and Pioneer Building. A horse-drawn wagon has stopped here, and there is a sign advertising "Charlie Ho Laundry" (right). The Weinberg Building is where Louis Weinberg had a clothing store (near right).

Looking eastward down Ridgewood Avenue from the railroad tracks to the Wilsey Building, this turn-of-the-century photograph reveals the then-prevalent dust from the dirt roads. In addition, low chimneys distributed soot and smoke from the coal and wood fires. Water came from wells, as indicated by the pump (lower center). The livery stable (right center) suggests the still-heavy reliance on horses.

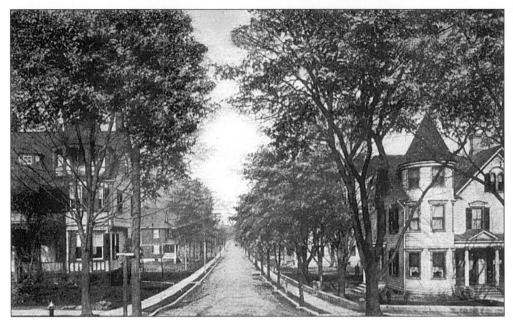

A residential area with stately houses in 1917, Walnut Street (looking north from East Ridgewood Avenue) slowly changed into a commercial zone by 1938, and the old homes fell victim to the bulldozer. The corner (left) is home to Hillman Electric, while on the other corner (right) now stands the U.S. Post Office. Gone, too, are the majestic trees that once graced these streets, victims of age, disease, or street widening.

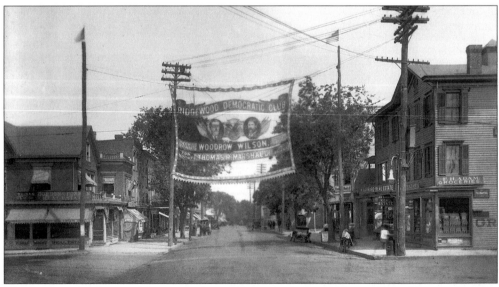

This picture of Ridgewood Avenue at Broad Street, with the 1912 presidential banner for New Jersey Gov. Woodrow Wilson, offers a few clues about those times under Ridgewood's first mayor, Democrat Daniel A. Garber. The Gordon and Forman realty firm, located in a building to be replaced in two years by the Wilsey Building, was across the street from other realtors, suggesting enough property transactions to sustain all three side-by-side.

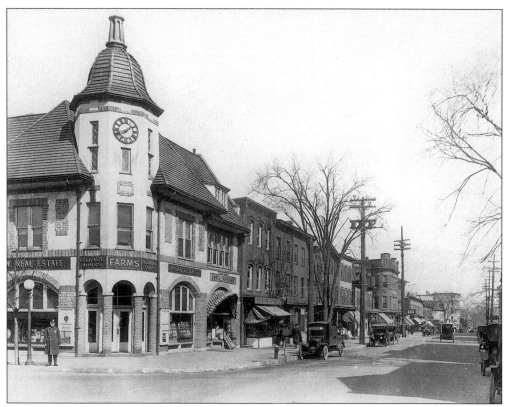

This northside view of East Ridgewood Avenue (*c.* 1920) shows a fully developed commercial district from North Broad Street to Chestnut Street and beyond to Oak Street. In the left foreground is the Wilsey Building. A butcher's shop is next door and, farther down, at the next corner (by the second telephone pole), stands the Pioneer Building, boasting a candy shop.

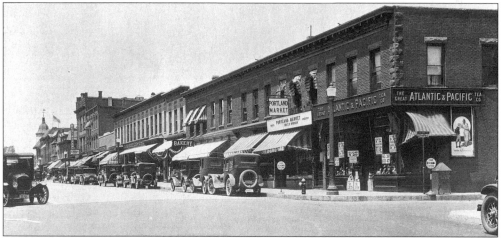

Another northside view of East Ridgewood Avenue (*c.* 1920) looks west from Oak Street, past McCrory's 5 & 10 and the Pioneer Building to the Wilsey Building. This scene offers a reminder of the days when A & P stores used a much longer name and operated as small grocery stores, allowing local shops (the next-door Portland Market butcher and the nearby bakery) to complement customers' other dietary needs.

Daniel A. Garber, twice mayor of Ridgewood (1911–1919, 1923–1927), was the primary force behind the creation of the railroad underpass, station complex, and plaza, making the village an equal construction partner with the Erie Railroad Corporation, which donated the land. This project eliminated the increasingly dangerous Franklin, Godwin, and Ridgewood Avenues grade crossings and helped open the West Side for development.

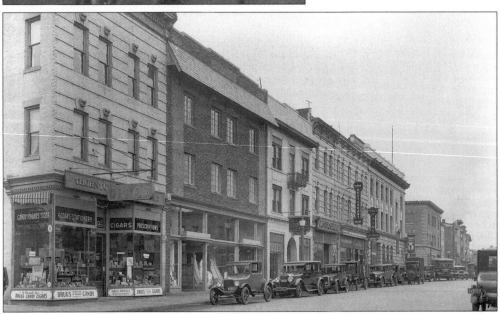

Looking west at the south side of East Ridgewood Avenue from Thornton's Drug Store at the corner of Oak Street (c. 1920s), we can see that parking was a problem then, too. In fact, a car is double-parked just past the paint and hardware store. Easily identifiable is the Ridgewood Trust Company building, with its side-mounted clock, and the original First National Bank Building, creating Ridgewood's "financial district" of those times.

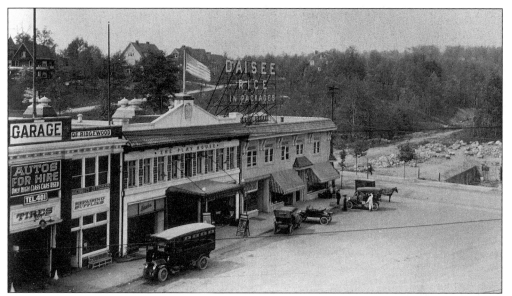

Houses in the Heights section rise above the Ridgewood Garage, the Play House, and Corsa Building in this northern view of Wilsey Square (c. 1910). As the right side of the photograph reveals, this road ended at West Ridgewood Avenue, as the latter continued directly eastward across the railroad tracks. Daisee was a popular food brand, and the sign changed occasionally to promote other company products.

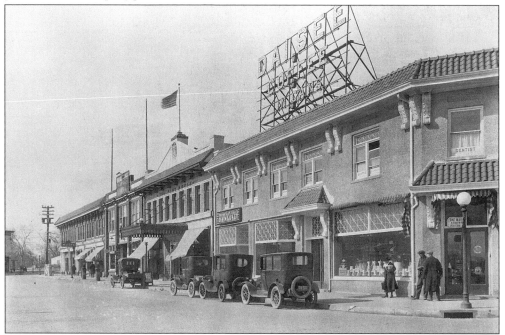

In 1922, the Daisee coffee sign dwarfed the Astor coffee sign in the window of the Manhattan Market below. Down the one-way brick street now known as Wilsey Square, past the O.K. Market and Play House, the gas pumps at the Ridgewood Garage and the music sign at the Stokes Building indicate the other commercial enterprises on this block. Note the architectural design harmony of bracketed pent roofs with cornices at the two corners.

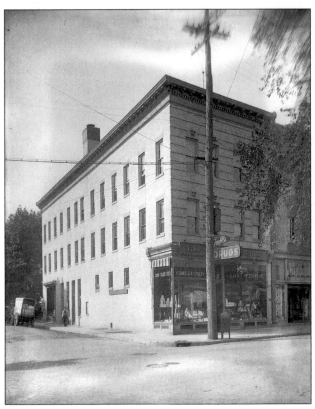

Literally the corner drug store, Thornton's was located at the corner of East Ridgewood Avenue and Oak Street, now the site of the Ridgewood Coffee Company. Like others in the early 20th century, this drug store offered other amenities such as a public telephone, strawberry phosphates and other delicious glasses of soda pop, Kodak Brownie cameras and film, and a variety of other products besides those listed on its windows.

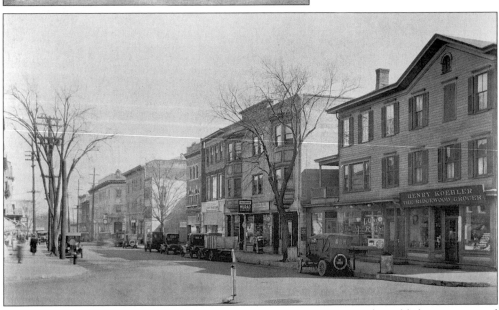

By 1924, Henry Koehler was the Ridgewood grocer, more commercial establishments existed (including a billiard parlor), and the Ridgewood Trust Company now boasted a large, outdoor clock. The greater number of parked cars offers one clue to the increased commercial activity (although hitching posts remained in front of the Lunch Room). A careful look at the roadway shows manholes and the cobblestone texture of the streets.

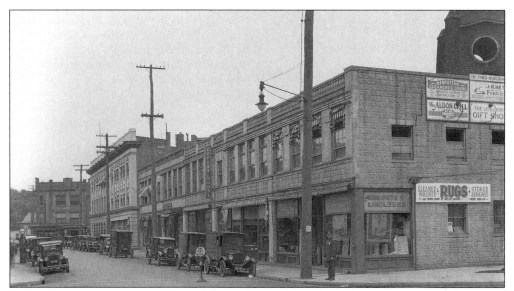

With the steeple of the Opera House in the right background, Prospect Street (looking north from Hudson Street towards the Ridgewood Trust Company on East Ridgewood Avenue, c. 1915) was a one-way street, as were most of the side streets off Ridgewood Avenue in those days. The vertical sign for a coffee house drew much attention three generations ago. Today's two coffee houses on Ridgewood Avenue continue to attract many customers.

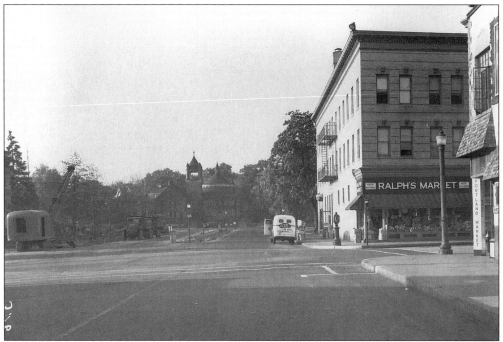

By the 1940s, Ralph's Market had replaced Thornton's Drug Store. As a Life Bread truck driver completes his delivery there, workmen across the street continue laying curbing on both the center island and along the edge of Van Neste Park, which was dedicated in 1931. By the rear of the steam shovel (far left) is the World War I memorial. In the center background stands the old, circular Methodist Church.

Henrietta Hawes (1871–1969), after whom Hawes School is named, was an outstanding community leader throughout her life. Following in the footsteps of her mother, Rebecca, who was a community activist, Henrietta served as Ridgewood's first woman president of the Board of Education. Among her many skills, she was also a licensed plumber.

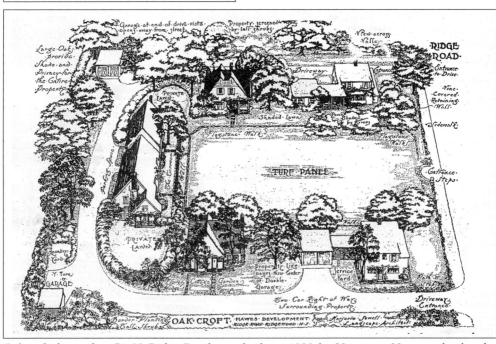

Oakcroft, located at 71-83 Ridge Road, was built in 1923 by Henrietta Hawes, who lived a block away, at 78 Crest Road. This group of six Tudor-style homes is significant for its site development. It combines otherwise private backyards into a "grand turf," preserving the oak trees and siting the houses to create an "outdoor room." Its landscape architect, Marie Sewell Cautley, used elements of this design in co-planning Radburn, a highly-acclaimed "new town."

38

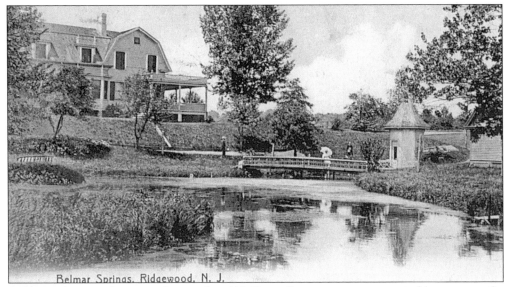

Belmar Springs, Ridgewood, N. J.

Fed by underground springs, this pond at 410 Grove Street was once a navigable waterway for canoes out and back into the Saddle River. Owned by David H. Wortendyke when this picture was taken in 1906, its residence and spring house are still standing. The property was soon divided and sold, and the springs tapped for commercial use by the Belmar ("beautiful water") Spring Company, which incorporated in 1915.

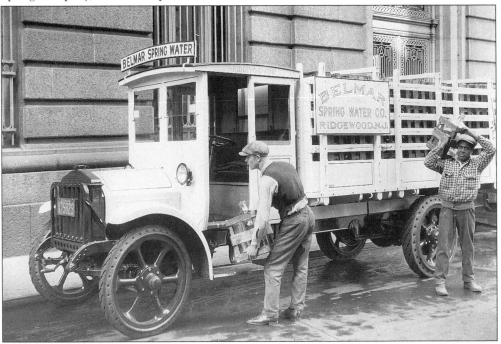

In 1925, brothers Edo and Clifford Outwater purchased the company, which continues today as a thriving family business for the third generation of the aptly named family. From their 1925 Federal truck, Belmar employees make a delivery to Paterson's prestigious Hamilton Club, one of their many city customers. Deliveries of five-gallon glass bottles was as familiar a sight at business offices as was deliveries of ice blocks for iceboxes at residences.

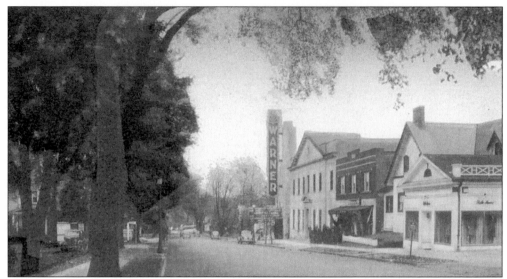

This view of East Ridgewood Avenue (looking east from Walnut Street in this mid-1930s photograph) shows some of the same trees (left) near the future site of the U.S. Post Office, constructed in 1938. The sign for the Warner movie theater, which was unable to show films on Sundays for decades due to local Sunday "blue laws," dominated this block. The Vroom House (second from right) had its stone exterior hidden by white stucco.

Except for the automobiles clearly dating this late 1940s photograph, this view of East Ridgewood Avenue (looking west from Oak Street) might otherwise appear, at first glance, to be a contemporary one. Changes in styles, storefront facades, and merchants mark the passage of time, but the historic preservation of the downtown district's architecture gives the area both the imagery and heritage from its past.

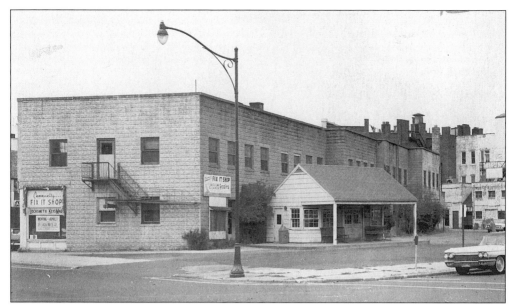

In October 1963, this was the appearance of the property bounded by Prospect Street, Dayton Street, and Van Neste Square. The Community Fix-It Shop occupied the corner of the building that earlier housed the floor covering store shown in the previous 1915 photograph. Where the Opera House once stood, there was a bus station, and nearby (but out of camera range, to the right) was a taxi-limousine stand.

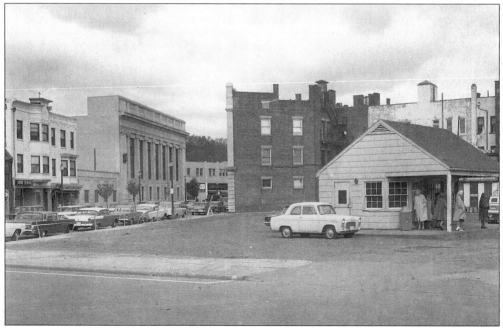

Just a few days after the above photograph was taken, the building was demolished by V. Ottilio, a Paterson contractor, the lot leveled, and covered with dirt to make way for a municipal parking lot. First National Bank (left) stands next to the rear of the buildings facing East Ridgewood Avenue. The bus station would soon moved—along with the taxi stand—to a new locale for a new purpose.

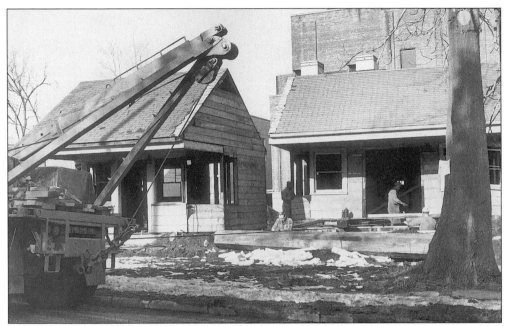

Moved side-by-side to a vacant, weed-covered lot at 109 Dayton Street behind the Warner Theater a year later, the forlorn bus station and taxi stand remained untouched for over two years. Finally, in October 1967, the Zoning Board of Adjustment approved their reconstitution into a two-room office building as the new home for the Chamber of Commerce. Remodeling work began immediately.

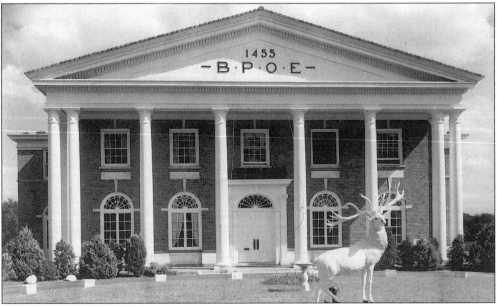

Before it was Village Hall, this building was an Elks' building. When the lodge first offered it for sale to the village in 1951, some citizens objected, forcing the issue onto a referendum in November 1952. Voters approved the purchase, 53% to 47%, but disappointed opponents carried their fight to the courts. The New Jersey Supreme Court dismissed the complaint in February 1955, enabling village officials to move into their new quarters in November.

Four

THE OLD HOMES
OF RIDGEWOOD

The estimated population of Ridgewood in 1880 was 500. An average of two to three new homes were built yearly between 1875 and 1885, then eight to ten yearly between 1885 and 1895, and ten to twenty yearly between 1895 and 1906. The spectacular growth period occurred between 1907 and 1911, when about 100 homes were built annually. By 1910, the census reported 5,416 inhabitants.

A large number of those turn-of-the-century homes remains in good condition today. According to the *Bergen County Historic Sites Survey*, what is special about Ridgewood is "the fact that whole streets, even whole districts, still handsomely represent in homogeneous effect the decade or decades of their settlement."

What makes these residential neighborhoods even more interesting, says the *Survey*, is that "architectural history is also exceptionally well represented in Ridgewood because of the diversity of its styles, which during this period between the Civil War and the First World War were numerous and eclectic in nature. There is little sophisticated 'high style' architecture in the village, but there is a superabundance of well-built, tastefully designed buildings–the product of skilled builders, builder-architects, and developers who consciously followed the ideal chosen, that of an upper-class residential community."

Space limitations prevent the showing of all, or even most, of the fine homes built during this period. Instead, a representative sampling is presented, many whose photographs were published in at least one of the following: *Picturesque Ridgewood* (1898), *Ridgewood Herald* (1919), *Ridgewood, NJ Garden Spot* (1927), and *Bergen County Historic Sites Survey* (1983). When known, historic names of the original owners are given.

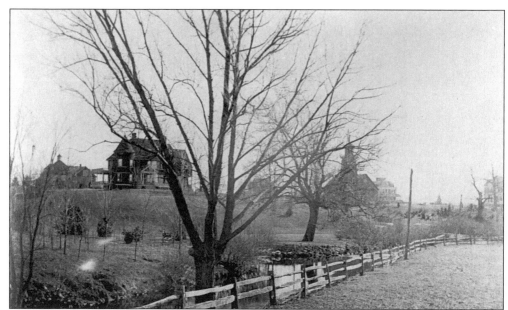

Ridgewood in 1899 was still mostly a rural community of around 2,600, as suggested by this southeastern view from the Ho-Ho-Kus Brook bridge on Ridgewood Avenue. The house on the hill, seen from its northern side and rear, was the residence of Dr. E.F. Hanks, who played a key role in building the Beech Street School in brick, in 1895. A barn-windmill (to the right of the house) is visible through the trees.

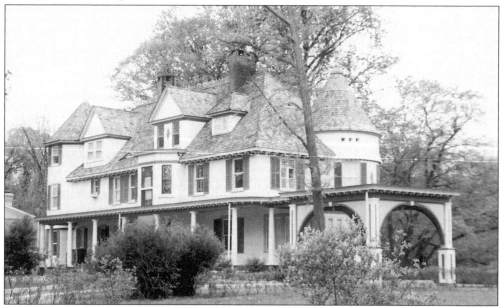

The Hanks-Boyd-Mastin House, located at 18 Brookside Avenue, was built in the early 1890s. Impressively set near the street with an expansive lawn in back, sloping down to the brook, the Hanks house passed to the Boyd family and then to the Mastins. It has an octagonal turret at the southeast corner, a cylindrical turret at the northwest corner, two interior chimneys, a *porte-cochere* and triple columns on stone pedestals, and a wrap-around porch on the northeast corner.

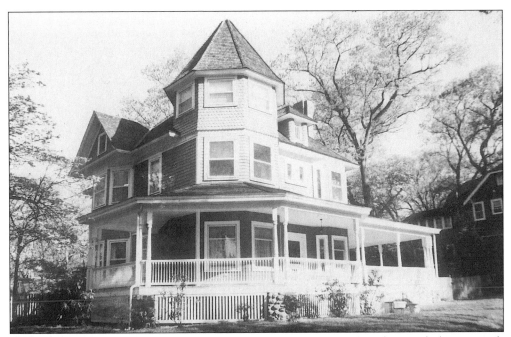

Located at 70 Crest Road and situated at the northwest corner with Ridge Road, this two-and-a-half-story Queen Anne has three bays and a pyramid roof. The southeast corner tower, wrap-around porch with slender columns on cobblestoned pedestals, and a spindle railing are characteristic of the 1890–1912 house. Enrico Caruso once stayed here for three nights.

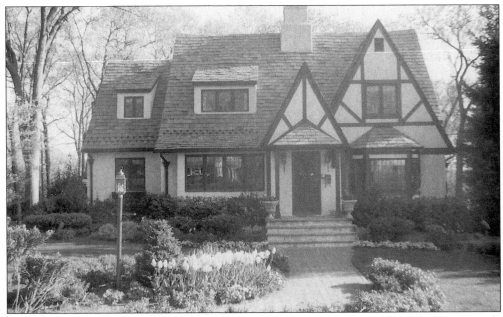

The 1912 Davison House, located at 257 Crest Road, is a charming, English Cottage-style Tudor house with stucco and varied windows of casement type. Its gabled roof has sharply peaked gablets, with a heavy, central brick, ridge chimney with chimney pots, a bay window, and half-timber decoration.

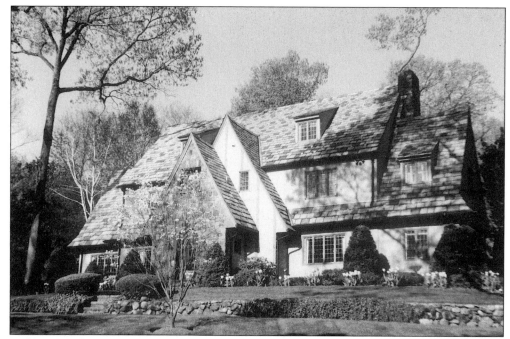

Built in 1912 by Warren Allabough, this 322 Crest Road stucco Tudor with five bays, casement windows, gabled with gable ends to the sides, has a slate roof with picturesque sagging in ridges and glaring out at lower corners. Its entrance is accented by overlapping gabled bays, and its arched doorway has vertical board paneling and iron hinges.

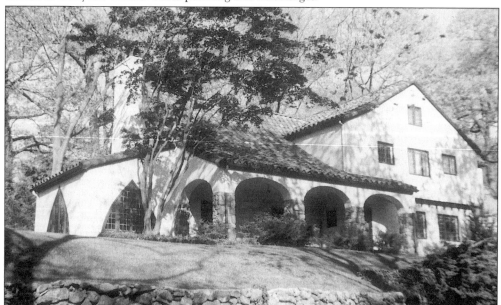

The south roof of this 1912 Spanish Eclectic Revival curves out dramatically to cover the open porch, with broad arches resting on stone piers. The shed-roofed south wing, with its unusual pointed-arched opening, and the north unit, with a second-story jetty on brackets, provide an interesting contrast to surrounding Crest Road homes of the Tudor style. This home is located at 362 Crest Road.

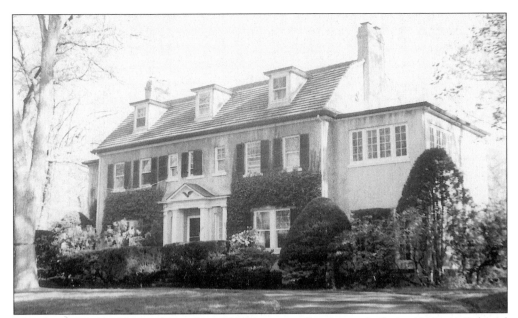

The Grant-Tucker House, located at 115 Fairmount Road, was built in 1912. A Colonial Revival with four bays, this two-and-a-half-story stucco house has two-story wings on either side. Its central entrance is framed with a double pediment and posts. Quarter-circle windows flank wall chimneys in the gable ends of the gambrel roof, while the wings (probably added) have flat roofs.

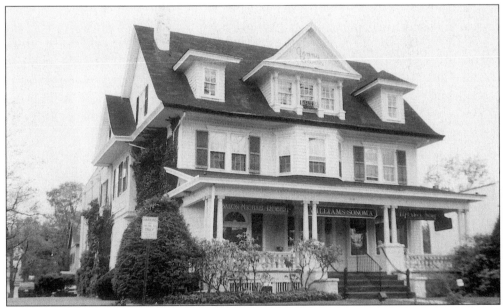

The 1900 Van Horn House is located at 216 East Ridgewood Avenue. Despite its conversion to commercial use, this is a well-preserved Victorian house in the Colonial Revival style, offering us a sense of the many big houses that once lined this thoroughfare. In 1946, Jenny Banta (1883–1969) moved her specialty shop, founded in 1927, to this location. Its restoration was the nucleus of an expansive restoration of the commercial east side of town.

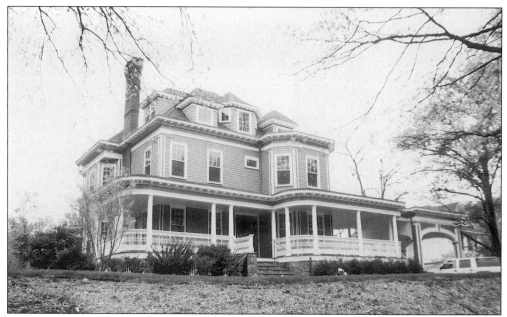

Located at 640 East Ridgewood Avenue, this impressive 1880s Princess Anne-style house is elevated on a terrace about six feet up from the sidewalk, with a large barn in the backyard. The house has an elegant wrap-around porch, conforming with projecting facade bays and extended to form the *porte-cochere*, Tuscan columns, and a spindle balustrade, with pilaster strips at the corners. William H. Hendrickson, a one-time owner, was a cement dealer in New York.

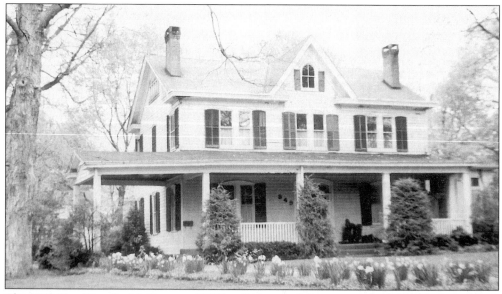

The 1861 Van Dien-Smith House at 849 East Ridgewood Avenue was located near the crossing of two major, early roads. This Vernacular Gothic Revival house, with a large barn and a saltbox profile in the rear yard, illustrates one of the picturesque styles followed in mid-century by Ridgewood's upper-middle-class residents. It has been altered by the loss of trim, the change of the porch to Colonial Revival style with Tuscan columns, cobblestone piers, and the replacement of some doors and windows.

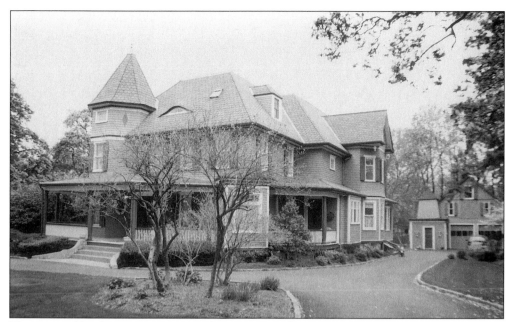

This view of banker George E. Knowlton's 310 Godwin Avenue house shows the truncated windmill at the end of the driveway. Probably built in 1890 by Joseph E. Christopher, this Queen Anne and Colonial Revival house has a hipped roof with hipped dormers on the west, eyelid dormers on the north, a gablet on the southeast corner, and an octagonal tower with a tent roof at the northeast corner.

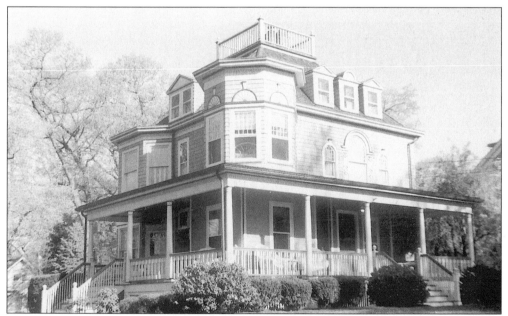

The Glaentzer House, at 50 Heights Road, was built c. 1890 by Joseph Christopher. This Princess Anne-style house has a vestigial tower on the southeast angle, with fan designs over the upper windows and a central-arched facade, window-framed by pilasters with geometric designs and flanked by smaller, arched windows. It also has three small, facade dormers with a fan pattern echoed in the central one, and a wrap-around porch.

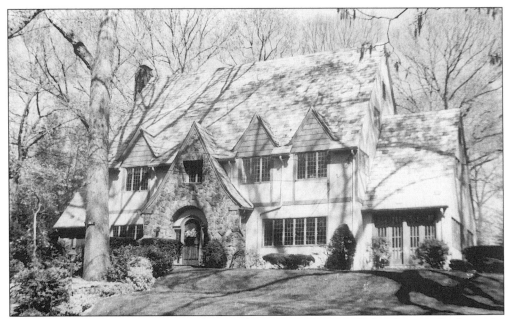

This 1912 Tudor, located at 307 Heights Road, is a stucco house with four bays on the first story and three bays on the second. Its two-and-a-half stories rise to a steep-pitched gable roof through one-and-a-half stories in the larger unit. The wall dormers, stone-end wall chimney, half-timber decoration, accented entrance with glared gable, stone surface and arched opening, and door all give this building its unique, picturesque charm.

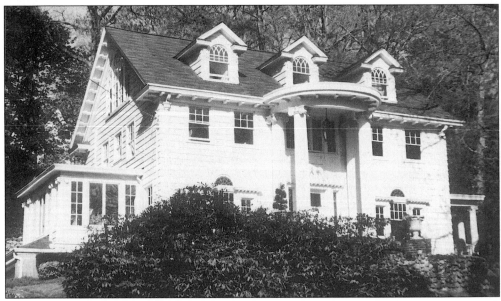

This 1920 Neo-Classical house at 372 Hillcrest Road is placed high on a terrace, with cobblestone retaining walls. It has a central monumental portico in a half-circle plan with Ionic columns, which are repeated in the glazed porch on the south wing. The dormers have arched, gable windows with upper gothic panes and flanking pilasters. The gable-end peak has arched windows with a fanlight.

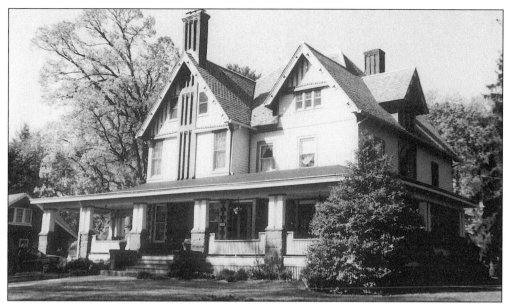

The Wheeler W. Phillips House, located at 256 Ivy Place, was built in 1865. One of Ridgewood's most important historic resources, it is one of the few remaining houses designed by Henry Hudson Holly, a prominent New York City architect and writer. Built of sandstone on the first story with its spacious rooms, it is framed and clapboarded above with vertical boards and battens. A high chimney stack on the exterior facade starts at the base of the second story and intersects the gable.

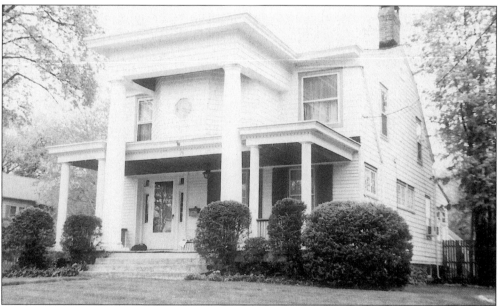

Located at 78 North Van Dien Avenue, the Garret Van Dien House was built in 1850. Home of Ridgewood's first postmaster, this Classic Revival front with its center monumental portico is incomparable to any other structure in the Ridgewood area. The one-story side porticos have a balustraded balcony between them. Garret was one of Ridgewood's earliest settlers and a dealer in groceries and provisions, and in coal and lumber.

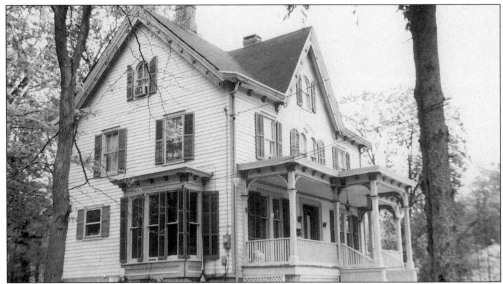

The 1861 Alexander House, located at 404 North Maple Avenue, is an excellent surviving example of a dwelling dating from Ridgewood's post-Civil War settlement period, on what was then one of the few main roads from south to north. It is architecturally significant both because it is so well preserved and because there are so few houses extant in Ridgewood of this style. Gothic Revival massing and detail with Italianate feature were typical of the period.

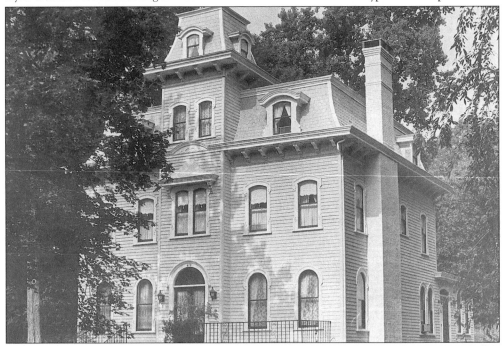

Shown here without its current roofed front porch, the 472 North Maple Avenue Arthur Walton House is an elegant example of Second Empire Victorian design. Its large center hall with original oak staircase leads to five bedrooms and three baths on the second floor, with four additional rooms above. Its extensive property facing Ho-Ho-Kus Brook presents a striking picture of a mid-19th century wealthy resident's home in the then-rural outskirts of Ridgewood.

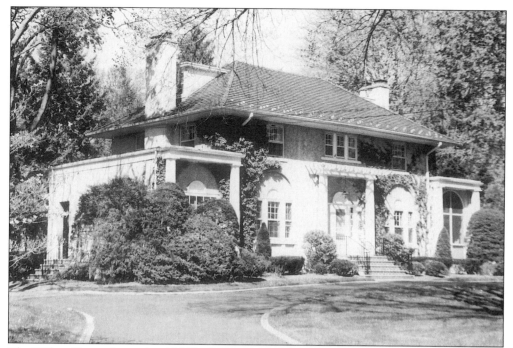

The Wilsey House, located at 123 Phelps Road, was built in 1912. Once the property of Walter W. Wilsey, this two-story stucco house is Mediterranean Revival with Georgian elements and a tiled, hipped roof. Its first-story facade door and windows have pseudo-Palladian design, with a wooden, carved fan over the central windows and window units surmounted with round arches.

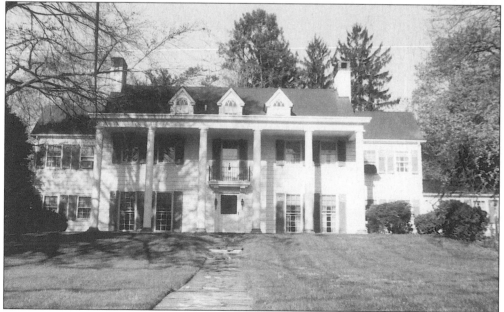

The Turner House is located at 168 Prospect Street. A 1904 Colonial Revival with an altered surface, this former home of Joseph Turner has a monumental six-column portico, end chimneys in the main section, and seven bays. It has gabled dormers with returned eaves and multi-paned arched windows. The one-story north wing is a later addition.

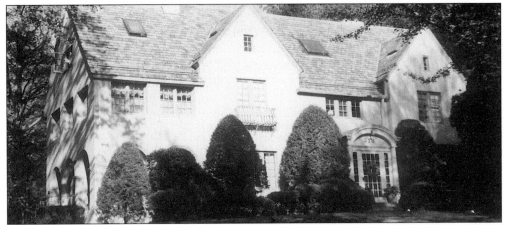

The Robbins House, located at 218 Prospect Street, was built in 1912. A Spanish Colonial Revival with five bays and multi-paned casement windows, this house has slide arcaded openings to the south end porch and a slated gable roof. Fred C. Robbins developed Kathawood Park and gave fanciful Native American names to such streets as Kemah Road, Waiku Road, and Wastena Terrace. He owned part of the Heights section known as Robbinswood (Crest, Heights, and Valley View Roads), which Warren Allabough bought from him and on them built some of the Village's most stately houses.

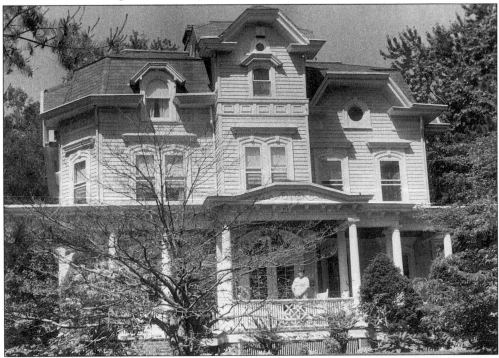

Located at 226 Prospect Street, the Watlington House was built in the 1870s. This imaginatively detailed Second Empire-style house is a pivotal one in the district and one of the most important of Ridgewood's historic resources because it is an outstanding, unaltered example of one of the community's oldest and most elaborate residences. Thomas Watlington, one of the first settlers in the post-Civil War period, ran an insurance business in New York City.

54

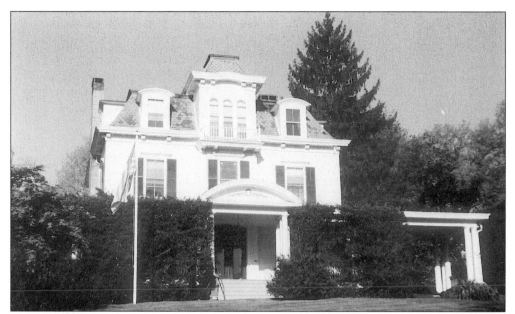

The 1867 Whitman Phillips House is located at 240 Prospect Street. Freestanding on the crest of Prospect Street hill, this towered, Second Empire-style house is a pivotal structure in the Prospect Street District and an outstanding example of Ridgewood's oldest, most elaborate residences. Whitman Phillips was one of the first settlers in the post-Civil War period, had extensive holdings, and was active in civic affairs. A later resident was Dr. John Aycrigg (1927).

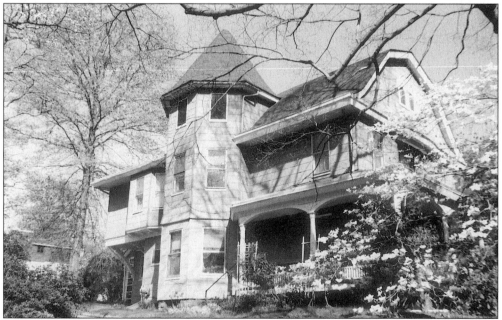

The Christopher House at 310 Prospect Street was built in 1890. A combination Colonial Revival/Dutch/Princess Anne house, this was the home of Joseph H. Christopher, one of Ridgewood's best-known builders. Some of the handsome village residences he built are featured in this chapter. This house is simpler than most of his designs but is of interest as an example of late 19th-century fusion drawn from varied elements.

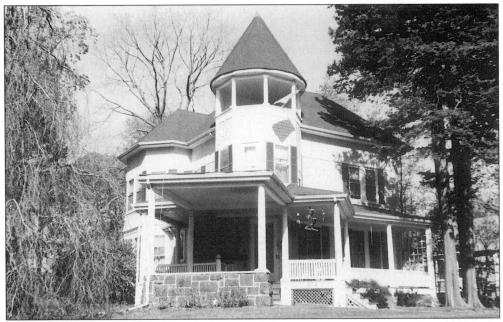

C.P. Crouter, a meat market owner and ice dealer who was also president of the school board, lived in this two-and-a-half story Princess Anne house, located at 324 Prospect Street. Most notable in this unaltered 1880 house is its corner tower with belvedere, tent roof, and frieze, with wreaths over the columns of the belvedere, wrap-around porch, and *porte-cochere*. The door is flanked by oval windows.

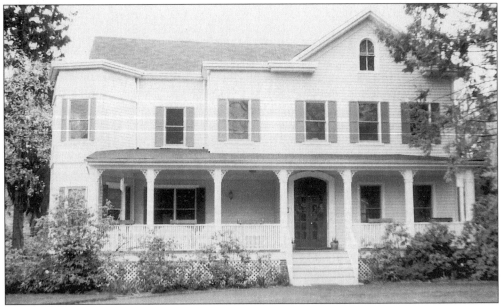

Located at 238 South Van Dien Avenue, the Zabriskie-Wadsworth House was built in 1861. One of the earliest mid-century houses in Ridgewood and the property of William J.D. Zabriskie and, later, artist Henry Wadsworth and Claudius Wadsworth (1904), this vernacular Italianate with a cross-gabled roof has a vestigial tower in a two-story octagonal bay at the southeast corner. The curved front driveway is shown on an 1876 map.

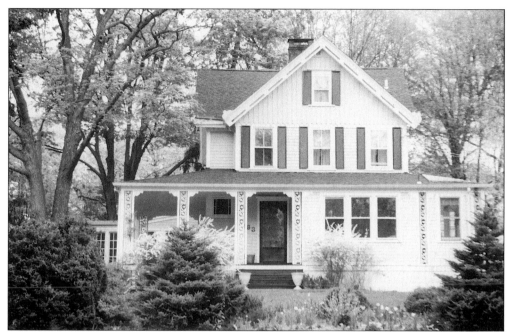

The 1876 Hales House is located at 363 Spring Avenue. Henry W. Hales, a prominent horticulturist, called his house "Floramere" and here started Ridgewood's first nursery, which supplied local and New York City markets with flowers, ferns, and palms. Hales photographed his plants and is credited with inventing such photographic aids as shutters, the flash lamp, and rolled film. The first house built on Spring Avenue and set back far from the street on a knoll, it has been altered by synthetic siding and a complete change of porch, but the basic massing remains.

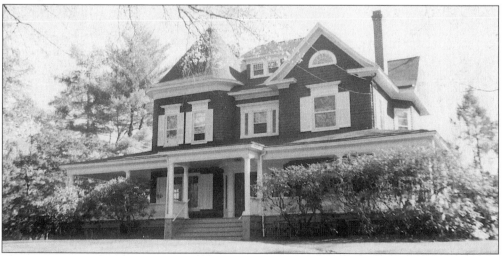

Photographer Theodore Obrig lived in this Queen Anne house with Colonial Revival features at 386 Spring Avenue. James H. Vanderbeck built the house in 1895. It has a tower on its eastern corner, with rounded corners and a tent roof. The glazed door has leaded, colored sidelights and the first-story window to the right of the door has a leaded-glass transom. The second-story windows have high entablature segments resembling Roman ressaults (with frieze, dentil, and cornice).

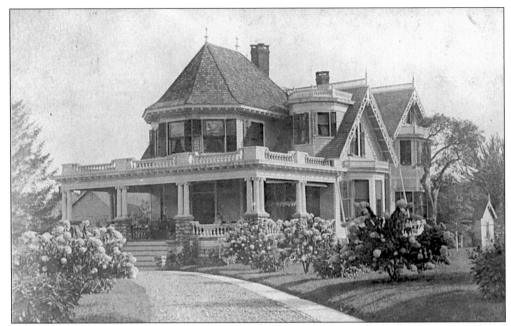

The Von Moschizisker House is located at 410 Spring Avenue. This 1897 American Foursquare-Colonial Revival, with a hipped roof and hipped dormers, has a large central chimney and second-story balcony extended over its front porch. F.A. Von Moschizisker was employed by the Erie Railroad and, in 1911, served on the Ridgewood Board of Education

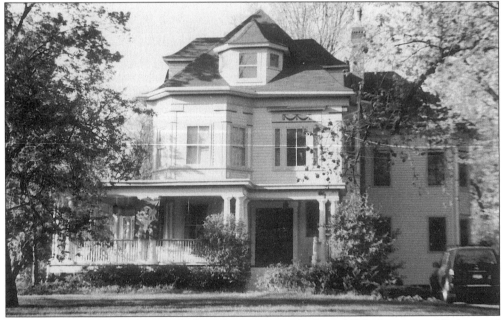

The 426 Spring Avenue home of John J. Lannvier was built in 1897. A trustee of Ridgewood (1907–1911) and president in 1907, Lannvier was also a director for Ridgewood's First National Bank. His house is Colonial Revival, with a stone foundation, wrap-around porch with grouped columns and spindle balustrade, and a double front door. The house has a large, brick-wall chimney on the west side, with recessed panels and an interior chimney as well.

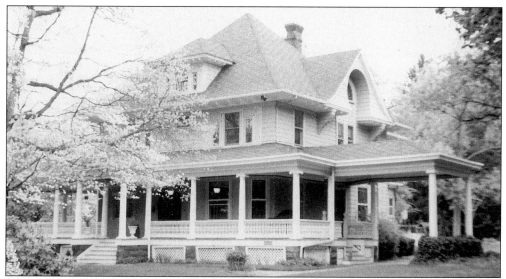

Built by Joseph H. Christopher in 1895, this Queen Anne-Colonial Revival combination is one of the most elaborate residences on Spring Avenue. The Silleck House, located at 448 Spring Avenue, is effectively situated on a terrace above the west bank of the Ho-Ho-Kus Brook. It has a flared, pyramidal roof with a hipped rear roof, a wrap-around porch with Ionic columns and a spindle balustrade, a *porte-cochere*, two interior corbelled chimneys, and a dramatically-treated gablet on the west side with a flared gabled roof. Charles D. Silleck was a salesman and later president of a large New York City manufacturing company.

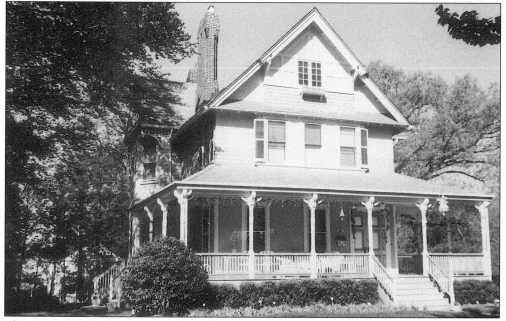

The Cantrell-Woolley House originally stood on Godwin Avenue, and was built in 1876. When moved around the corner to 131 West End Avenue, the wrap-around porch was removed and the *porte-cochere* added. Except for loss of the porch, this handsome residence has been preserved and is an important survival of the elegant homes built by wealthy men settling in the southwest area of the village in the late 19th century.

The 1810 Garret Ackerman House at 570 West Saddle River Road is a handsome, well-preserved house and an outstanding survival from the early 19th century. Typically placed facing south, at right angle to what was then one of the major routes along the Saddle River, it still presents a clear image of a fine homestead. It has nice details, including the entablatures over the windows, the small "eyebrow" (or frieze) windows, and the porch. The whole structure has a balanced design.

Commissioner George U. White moved into this 260 Woodside Avenue, 1890 Queen Anne house after George F. Kohler. Its cross-gabled roof is set off by a tall, corbelled brick chimney on the south. The building has a brick foundation, paneled friezes over the south ell, bay windows on the north ell, a wrap-around porch with turned posts and brackets, and notable accents on the central facade.

Five
HISTORIC DOWNTOWN DISTRICT

The 20th century brought significant growth and development to Ridgewood. Between 1907 and 1911 occurred the largest development of real estate in the history of the village, when an average of 100 new homes a year were constructed. During the period from 1912 to 1915, an average of 35 new homes a year were completed. In 1916, fifty new houses were built. Such population growth—which steadily continued—enabled the downtown district to evolve into a greater commercial center than ever before, prompting the construction of buildings, particularly in the first quarter century, that resulted in the character and imagery we cherish today.

From just a few stores providing the essentials of daily life, the downtown district grew into a central business district, with commercial establishments of all kinds offering a rich variety of goods and services. Elsewhere in this book, the growing entrenchment of the commercial district on residential areas is illustrated. Here, the focus is exclusively on the Historic Downtown District, as designated by the Village Council in 1994. A seven-member Historic Preservation Commission maintains the character and ambience of this area.

The following walking tour, as indicated on the map, begins at the railroad station on the southbound side, proceeds south to West Ridgewood Avenue, continues under the railroad tracks to East Ridgewood Avenue for four blocks, and ends at the Education Center on Cottage Place. Most buildings are designated by their historical names. The tour is about one mile in length and can be completed in less than an hour.

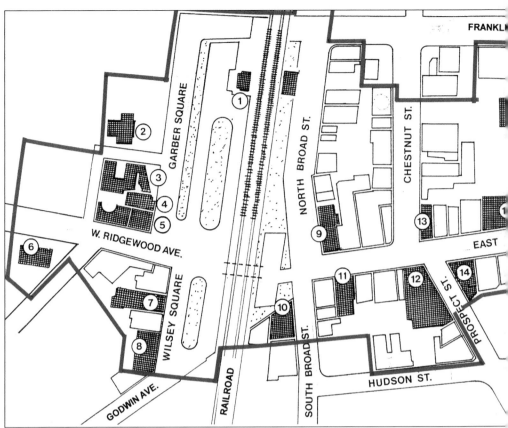

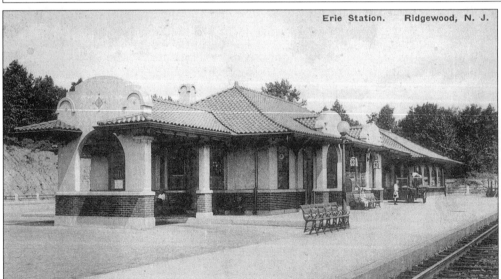

Erie Station. Ridgewood, N. J.

This railroad station (1916) is #1 on the map above. The mission-style architecture—popularized in California in the 1890s—is unique in New Jersey. Its distinctive features include round arcades, shaped gable ends, smooth stucco finish, and a Spanish tile roof. Frank Howard, one of the two Erie Railroad engineers who designed the station, brought that stylistic convention with him when he moved east and settled on Maple Avenue.

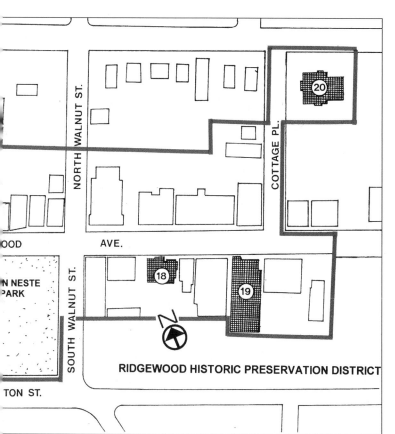

Shown here is a Walking Tour Map of Ridgewood's Historic Downtown District.

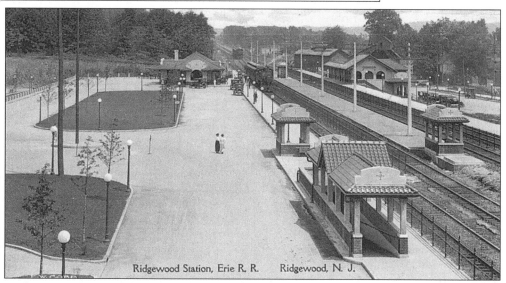

Garber Square (1916), the landscaped area in front of the station, along with the construction of the vehicular underpass and the pedestrian underpass (near right) was an integrated construction project that cost $160,000 and was completed in 13 months. Both Garber and Wilsey Squares were reserved by the Erie Railroad for future track areas for layovers, but they remain park-like parking areas to this day.

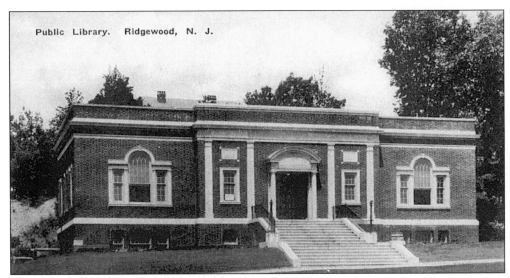

Public Library. Ridgewood, N. J.

George L. Pease Memorial Library (#2 on map) was located at 130 Garber Square in 1923. Designed in the Italian Renaissance Revival style, this building is an outstanding example of Palladian library design so popular in the United States in the 1920s. Situated on a hillside, this building—with its four Palladian windows, fine Flemish bond brick, and elegant limestone accenting the design details—has a commanding presence in the landscape.

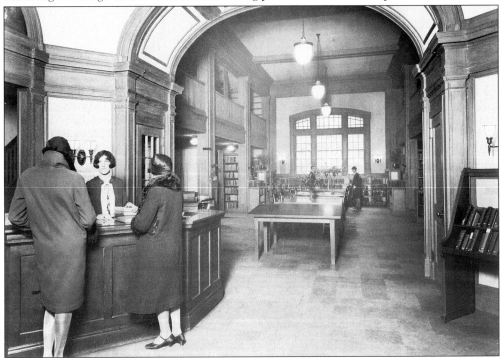

The spacious library interior—with an open plan, dark woodwork, a skylight, and a mural decoration—is trimmed with Renaissance details, oak trim, and wainscoting throughout. Designed by architects Henry Barrett Crosby and Albert Marten Bedell, the library (a bequest by Gertrude Pease Anderson in memory of the father who was a notable early resident) was built at a cost of $100,000.

This apartment house (#3 on the map on page 62 and 63), 20 Garber Square, is from the late 1920s. This English Tudor-style manor with exuberant details provides a framing for Garber Square. It has varied windows and rooflines, half timbers, wall dormers, quatrefoil designs in wood panels, and Tudor upper stories. Interestingly, the building is placed on a low terrace with cobblestone walls and angled to visually lead to the library.

This commercial building (#4) at 10 Garber Square is from the late 1920s . This two-story, Mediterranean Revival commercial building, with its varied picturesque detail, offers a strong contrast to the Corsa Building next door but is related to the California mission-style railroad station that it faces. Its varied details include a parapet with profiles that are in part crenellations and in part Moorish arches, a tiled bracketed roof, and a wrought-iron balcony.

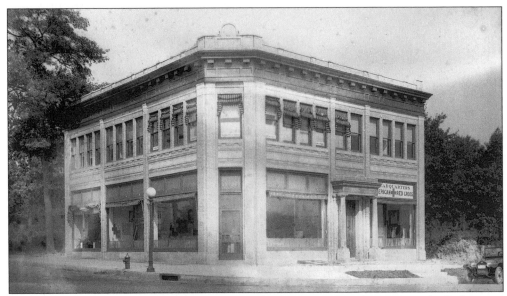

The Corsa Building (#5), at 2 Garber Square, is from 1912-19. Headquarters to the Ridgewood Red Cross in 1919, this was the first building on this block, and it dominated the intersection. It has many Renaissance decorative details, a deep copper-pressed cornice frieze of triglyphs and disks, a surrounding balustrade, pilasters that divide the facade into three units, one-bay central entrance porch with columns and entablatures, and a double-glazed door with a transom.

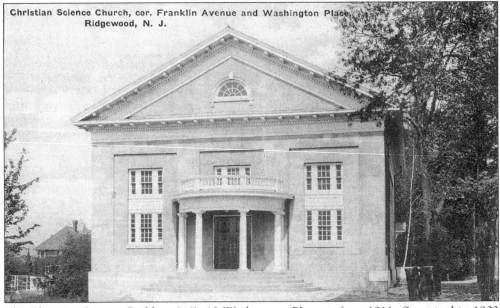

The Christian Science Building (#6), 10 Washington Place, is from 1911. Organized in 1903 with ten members, the Christian Science Society met in the public library, then located on the second floor of the First National Bank Building. The First Church of Christ Scientist, Ridgewood, a branch of the mother church in Boston, had its cornerstone dedicated in 1911, and its first service held in 1912. It is a Greek Revival design, favored by the church at that time.

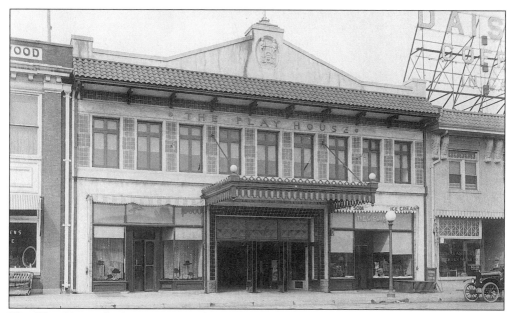

The Play House (#7), at 12-16 Wilsey Square, is from 1913. Built by Walter Wilsey, the Mediterranean-style facade and stucco building was inlaid with brown tiles on the second level that recalled the decoration of the interior. An entrance overhang separated the two ground-level stores, and during shows a billboard sign stood outside. Alterations now hide its original use, but the configuration of a theater flyloft is still distinguishable at the rear of the building.

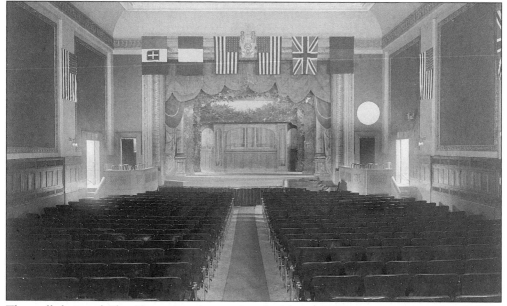

The well-designed Play House interior, equipped with a $5,000 organ, accommodated about 400 people. Mayor Garber officiated at its opening, which included a comedy in four acts, *Trelawney of the Wells*, performed by local young people. The building served as a site for many local theatricals, as well as a place of assembly for community social and civic activities, and "high-class moving pictures" at other times.

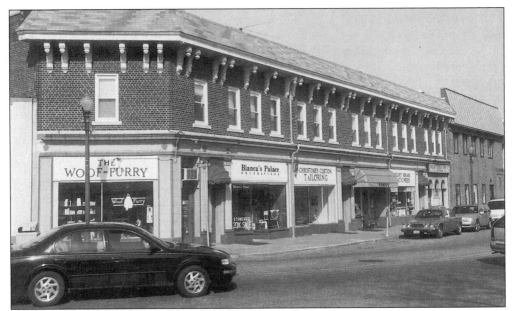

The Stokes Building (#8), at 28-36 Wilsey Square, is from 1913. This long, two-story building accommodates shops at the street level and apartments above. It is vernacular in design with classic revival trim. Despite alterations, the facade has retained its integrity with a bracketed pent roof with cornice, a frieze between stories, and wide transoms above ground-floor shop windows. Among the stores here in 1927 was the Ridgewood Talking Machine Company.

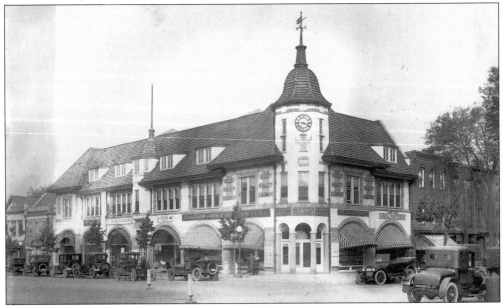

The Wilsey Building (#9), at 1-3-5 East Ridgewood Avenue, is from 1914. A three-story eclectic Tudor-revival building named for Ridgewood's prolific builder, Walter W. Wilsey, its arched facade facing the railroad station and its plaza are particularly well proportioned. The corner tower with its bell-shaped roof, weathervane, and clock form an enduring image of Ridgewood's downtown, particularly for railroad commuters and travelers of nearby highways.

Walter W. Wilsey (1875–1927) was one of Ridgewood's major builders. He left his mark on Wilsey Square, the Play House, the Wilsey Building, and the Franklin-Maple Apartments, the village's first and only high-rise apartment building. He developed housing in the Fairmount-Phelps-Heights Road area, and today his descendants are still involved with the real estate industry.

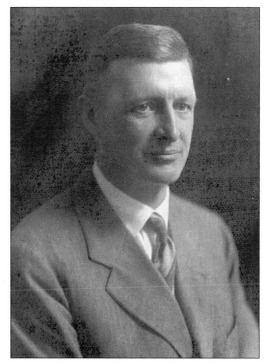

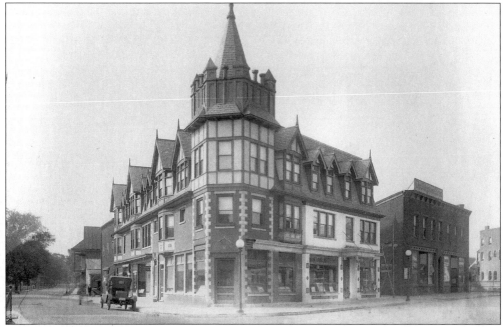

The Moore Building (#10), at 12 East Ridgewood Avenue, dates from 1910-15. An eclectic mixture of styles (Medieval, Gothic, Tudor), with varied gable dormers with pinnacles and a corner tower with turrets and finials, it is constructed of brick, stucco, and timber. As a striking southwestern terminus for East Ridgewood Avenue, together with the Wilsey Building's clock tower, it creates a "romantic heart" as the focus of the historic downtown district.

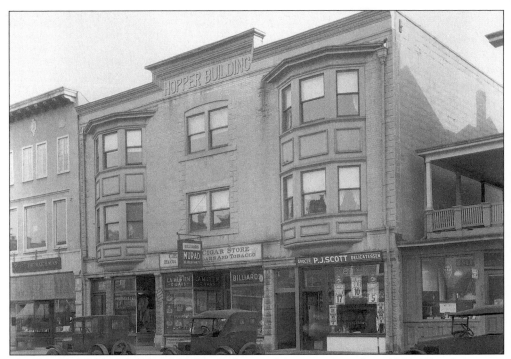

The Hopper Building (#11), 28-32 East Ridgewood Avenue, dates from 1908. This three-story building was built by Abraham Hopper, who was active in the development of the village in the 1880s. Many fine details enhance the vernacular style, such as the parapet with the building name inscribed and the vertical elements emphasis on the facade. Flanking the paired center windows are projecting triple window bays, united by panels and separately roofed.

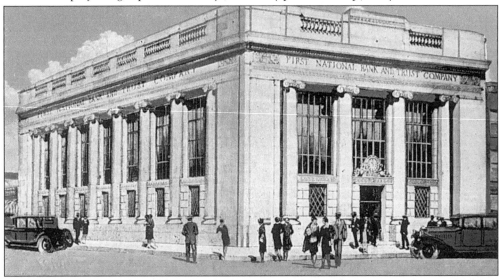

The First National Bank Building (#12), at 56 East Ridgewood Avenue, is from 1930. Now Fleet Bank, this handsome classic revival building has limestone ashlar facing over brick curtain walls, dentil molding, frieze, monumental Ionic columns in the front, Ionic pilasters on the side, a band with Greek fret designs, and a clock in a circular frame with its shoulders decorated with cornucopias and fruit.

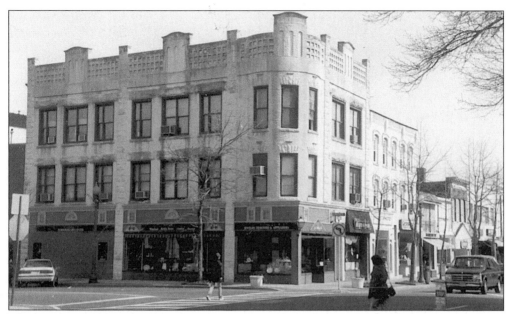

The Pioneer Building (#13), at 31 East Ridgewood Avenue, is from 1900. This example of vernacular Renaissance Revival style may be the oldest surviving, commercial building in the district. It once housed one of the first telephone exchanges in Ridgewood. Of particular interest are the battlements, checkerboard paneling, and the window treatment with two bays of triple windows facing Oak Street and a bay of paired windows facing East Ridgewood Avenue.

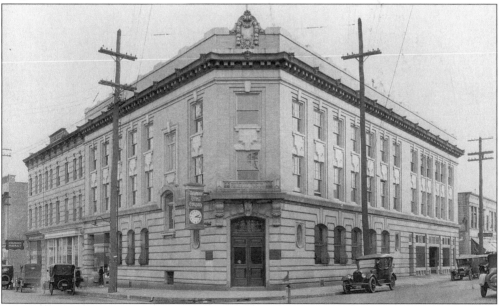

The Ridgewood Trust Company (#14), at 60 East Ridgewood Avenue, is from 1910. Now the site of Town and Country Pharmacy, the elements of this Renaissance Revival building are still visible despite alterations in the ground-level commercial facade. The elaborate parapet (wall) has a cartouche framed with scrolls, swags, and wreaths over the corner entrance. Panels with stepped profiles vertically connect the windows.

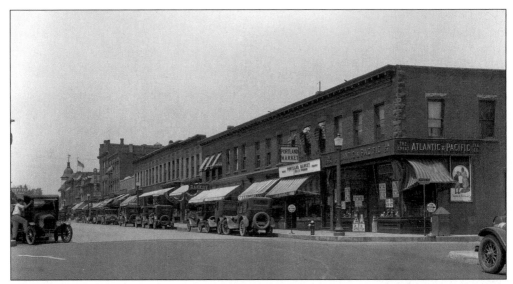

The Hanks Block (#15), at 57-67 East Ridgewood Avenue, is from 1903. This vernacular-style building, then owned by Dr. E.F. Hanks, has a commanding site on the block in which it is situated. The cornice has exposed rafter ends and dentil molding, and there are corner quoins and pent roofs over two of the shops. Originally, there was no corner entrance as there is now, and apartments were located on the second floor.

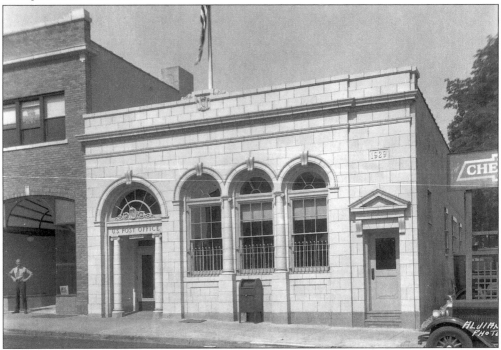

The old post office (#16), at 36-38 Oak Street, dates from 1929. This small building is notable for the elegance of design in its facade, as an adaptation of Renaissance style, and for its various functions in the community as a post office until 1943, a municipal building until 1955, and then home to the *Ridgewood News* through the 1980s. Note the roof with parapet cornice, plain frieze, egg and dart moldings, Ionic columns, and fanlights.

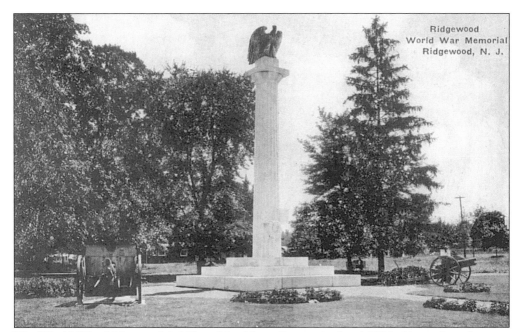

The World War I Memorial (#17), at Van Neste Square, is dated 1924. Situated on the west side of the square, this Classic Revival memorial column was designed by Henry Bacon, who was the architect for the Lincoln Memorial in Washington, D.C. Made of granite, with a bronze eagle, it was dedicated to the sons of Ridgewood who died in the war. In 1964, a Roll of Honor for World War II was erected as were other Rolls of Honor for the Korean and Vietnam wars.

The Archibald-Vroom House (#18), at 162 East Ridgewood Avenue, is from 1789. This sandstone house, built by John Archibald, is on the National and State Registers of Historic Places. It was occupied for decades by Dr. William Vroom, who came to Ridgewood in the "Blizzard of '88" and stayed to deliver 3,000 babies and establish the community first hospital. Dr. Vroom pioneered the use of insulin and diphtheria antitoxin.

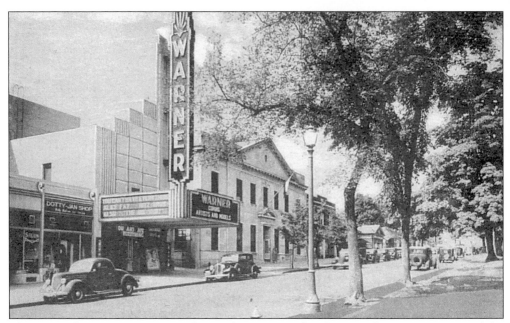

The movie theater, at 190 East Ridgewood Avenue, is dated 1930. This representation of the Art Deco style is actually a brick building with concrete facing. There are three double-glazed doors with brass framing, and marble overlay on the side walls of the facade. Vertical emphasis is achieved with set backs and geometric massing, staccato shapes and colors for ornament.

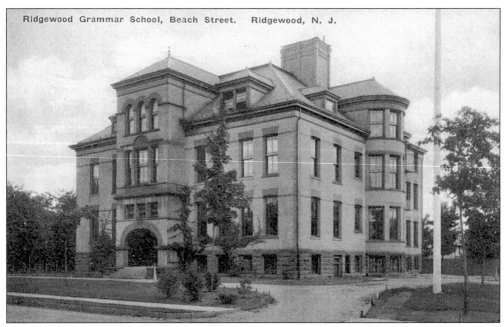

The Beech Street School (#20), at 49 Cottage Place, is from 1894. Now the Ridgewood Education Center, it was built by Joseph Christopher, Ridgewood's major builder in the 1890s. A massive Romanesque Revival building, it is built of brick instead of wood because women in the community so petitioned. It is one of the village's most important historical resources and is listed on the National and State Registers of Historic Places.

Six

COMMUNITY LIFE

Residents took an extensive interest in all matters relating to community life through the churches and their various organizations, or through clubs and other societies, as a means of social and civic exchanges. Clearly, the churches provided an important community focus, not just in nourishing the spiritual lives of their congregations but also in offering opportunities for civic and social events. Schools, too, presented numerous contributions to community life in musical and dramatic productions, athletic events, and social events in addition to their primary mission of education.

Central gathering places, besides the churches and schools, were many and varied. A favorite outdoor place for Sunday afternoon church services during the summer months, mass meetings, or Independence Day celebrations was Pearsall's Grove on the north side of East Ridgewood Avenue, between the Ho-Ho-Kus Brook and North Maple Avenue. There stood, said a 1916 writer, "a charming grove of trees which follow an uprising of the land from the street level to the summit of a ridge from which there is an excellent view, the whole being admirably adapted to open air gatherings."

Favorite indoor places included the Union Street School Hall (scene of Ridgewood's first public concert in 1878), the Opera House, the Play House, Wilson's Hall on Broad Street until it was destroyed by fire in 1881, and other halls on the upper floors in the Ryerson Building, Prospect Building, First National Bank Building, and the Wilsey Building. Facilities at the Country Club, Town Club, and White Star Athletic Association also were scenes of numerous social affairs.

The first Union Street School was a two-story, two-room structure built in 1872. Closed in 1895 when the Beech Street School opened, the school was razed in 1903. The second Union Street School, built in 1905 and pictured above, had a four-room addition the following year. Closed in 1966 with the opening of Orchard School, it served briefly as a youth center, then was sold at public auction and converted into its present form as apartments and offices.

This 1910 photograph of the Union Street School teachers, taken in the office of Principal Maggie Vreelans (seated, center), captures not only the clothing and hair styles, but also the then-common roll-top desk, two-piece telephone, and large bell connector box on the wall. By this time Ridgewood's school population neared 1,200 and was distributed between four schools, Beech Street, Kenilworth Place, Monroe Street, and Union Street schools.

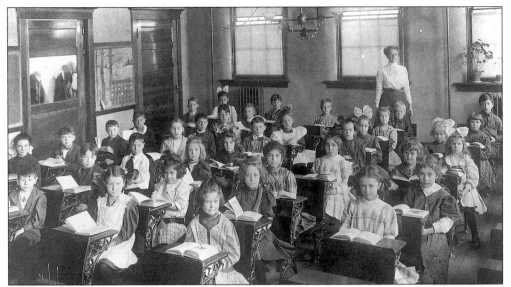

Overcrowded classrooms were a continuing problem in the early 20th century, as suggested in this Union Street School classroom. In 1911, the Harrison Street School opened, and both Kenilworth and Monroe Street schools had seven-room additions. In 1912, school officials set up a one-room portable building at the newly acquired site at Morningside Road and California Street, and then set up three portable buildings the following year on Beech Street School grounds.

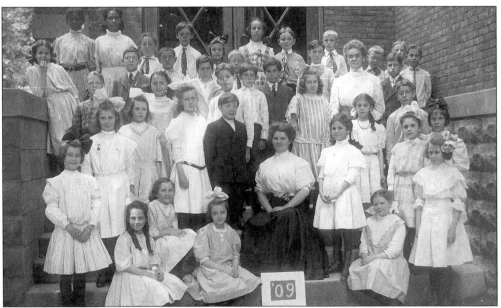

Dressed up for the occasion and posing proudly on the steps outside the Union Street School, the Class of 1909—born in the previous century but destined to live most of their lives in the 20th century—anticipate their future. Most went on to attend Ridgewood High School, then located in the building that now serves as the Education Center at Franklin Avenue and Cottage Place. A few would later face the grim realities of war on European battlegrounds in 1917-1918.

With the completion of Ridgewood High School in 1919, these students were the first football team members to don shoulder pads and helmets to play at the new facility. For the graduating seniors, this new setting marked their final year on the school's varsity grid squad. In the last row (far left) is Principal Irwin Somerville, Coach Earl Abbott Thorn (second from right), and Robert Tennant, faculty advisor (far right).

Named after Amelia Bloomer, who c. 1850 advocated similar girl's clothing, bloomers were loose trousers gathered at the knee, worn by women as part of riding, gymnasium, or other like dress. Sitting in 1919 on the steps of Ridgewood High School with their gym teacher, Elizabeth Sellier, eight of these "bloomer girls" still resided in or near Ridgewood by the late-1950s and were grandmothers, club leaders, and career women.

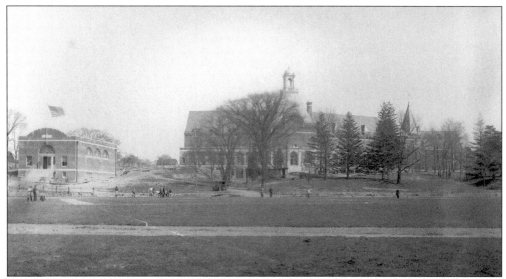

Taken shortly after its construction in 1916, this photograph of Ridgewood High School shows the gymnasium considerably separate from the main building. A wooden walkway and stairs connect the two buildings. Readying themselves, for either baseball practice or a game, is a group of young men, many of them in knickers. The grounds are far less aesthetic in appearance than today.

The evolution of the high school complex, as shown in this 1962 aerial view, shows its additions in 1931, 1937, and 1962. The most recent additions were the new gymnasium and industrial arts wing in the left background; in addition, the new classrooms, student commons, and library facilities were provided in the new wing in the right background. The chapel, part of the original building was enlarged and renovated.

The old Ridgewood YMCA building, dedicated in 1906, was located on the site of the present south parking lot of the YM-YWCA on Oak Street. When the YWCA and YMCA pooled their resources in 1951 to build the present structure, it became the first Y in the United States built for the joint occupancy of the two organizations, resulting in a feature story in *Life* magazine.

The massive, brown Opera House—located where the bus station and parking lot opposite Van Neste Square now stand—offered numerous local and road-company productions, dancing classes, charity bazaars, and occasional movies. Built in 1894 and refurbished in 1913, its grounds were the site of numerous carnivals and fairs. In 1902, the newly created Ridgewood YMCA rented rooms in this facility that included a reading room, billiard and pool parlors, a gymnasium, hot and cold baths, and bowling alley. Woodrow Wilson once gave a speech here.

Benjamin Robinson, a New York vacationer to the area during the summers of 1850-1852, settled in Godwinville in 1853. His years of lobbying efforts led to the establishment of a Ridgewood post office in 1865, and his appointment as its first postmaster, with an annual salary of $10. When a federal law forbade him to simultaneously hold both that position and one with the Internal Revenue Service; he resigned as postmaster in 1866.

Garret G. Van Dien served as postmaster from 1866 until his death in 1884, operating out of his and his brother John's general store, located where the Wilsey Building now stands. Installing the village's first telephone in his home in 1882, he quickly found it a nuisance, as Paterson undertakers frequently called him for information about people who had died, and so he had it removed within a year.

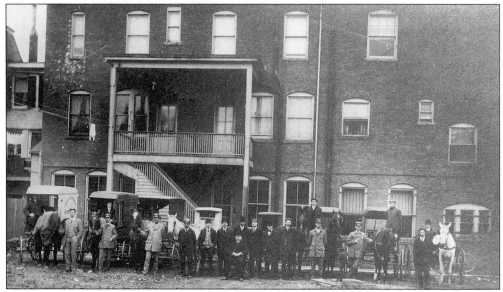

The post office's territorial limits then included East Paterson, Fair Lawn, Glen Rock, Paramus, and Rochelle Park as well as Ridgewood and its rural environs. The Ridgewood postal clerks (center) and their out-of-town carriers (with horses and wagons) pose in 1909 behind their workplace. At that time the post office was located in the Van Dien Building on the corner of East Ridgewood Avenue and Chestnut Street.

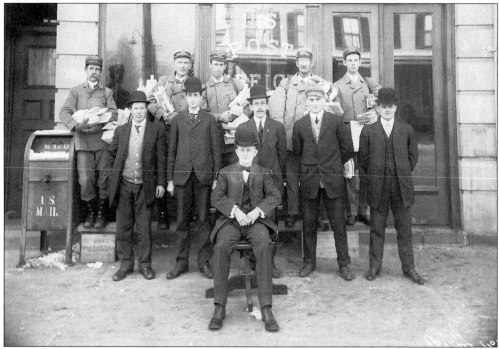

In 1912, the post office relocated to larger quarters at 208 Prospect Street, adjoining the First National Bank Building. Postmaster Roger M. Bridgman (seated) had five clerks and five regular carriers just to serve Ridgewood. By 1916, personnel had increased to 22, eight of them regular carriers, and some others as carriers for the newly installed parcel post system.

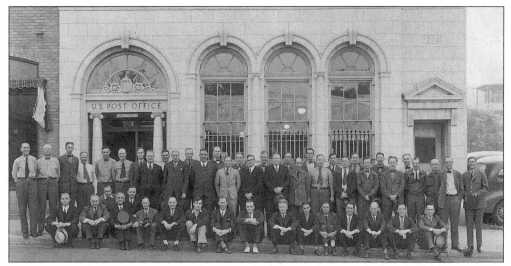

Expanded operations necessitated a larger work facility by 1929, and a local merchant, Ernest Cobb, built a building at 40 Oak Street that the post office rented until further community growth forced relocation to the present site. This marked the first time postal employees worked in a facility designed for them. This 1938 photograph shows most of that larger work force (totaling 57, including substitutes) to meet Ridgewood's needs.

When a touring group of chiefs from the Sioux Nation came to Ridgewood in 1920 to appear at the Opera House, village officials greeted them at Paddy Burke's Mansion House on East Ridgewood Avenue. Commissioner Thomas J. Foster is at the left and Police Chief Fred J. Blackshaw is in the center. At the far right, Mayor John B. Hopper shakes hands with the Sioux chief said to be the model for the five-cent Indian-buffalo coin.

A taxi stand at the train station has been a long-standing tradition, but in the 1920s passengers arriving in Ridgewood secured one at Garber Square, where cars for hire parked on the inlaid brick. Behind the taxi is the Corsa Building and, to its left in the background, sits the Christian Science Church. The three parked cars behind the taxi driver, as well as the lack of any moving vehicles, suggest an easy traffic flow in those times.

In response to demands from residents living east of Ho-Ho-Kus Brook for fire protection closer to their homes, Eagle Hose Company No. 1 came into existence in 1900. Soon thereafter, Ridgewood had its first fire hose wagon. Here, a group of local citizens inspect the new acquisition in front of Benjamin Eglin's blacksmith shop. In derby hats and Chesterfield coats are future fire chief Jesse Van Wegenen (second from left) and George W. Courter (far right).

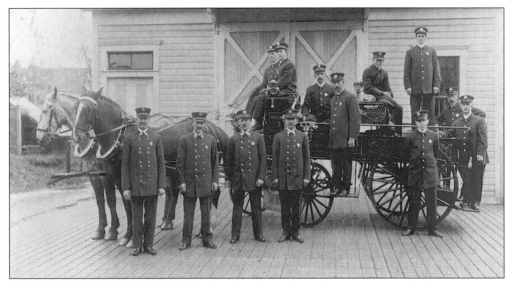

Posing in their dress uniforms in 1914, firemen from Eagle Hose Company No. 1 proudly stand outside their station at 19 Circle Avenue, built for them by village blacksmith Benjamin Eglin. With them are Dan and Joe, the fastest and most famous of all the department's horses. They served until 1924, when the department became fully motorized, but continued on with the Street Department until Joe died at age 30 in 1934, and Dan died at age 35 in 1938.

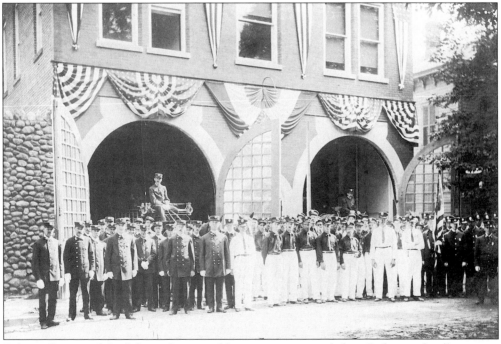

Police officers and firefighters from neighboring towns joined their Ridgewood colleagues in front of their new Hudson Street facility on July 4, 1911. All were participants in the village's second Independence Day parade, an event so successful that the Independence Day Association became incorporated. By 1916, it consisted of 238 individuals and firms dedicated to observe Independence Day "in a fitting manner."

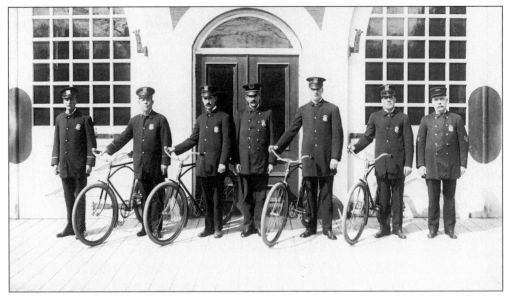

Ridgewood's mobile patrolmen pose outside the Hudson Street municipal building with their bicycles (*c.* 1916). An outgrowth of the Village Protective Association formed in the early 1890s, Ridgewood's police department—at the time of this picture—included a superintendent of police, one sergeant, seven patrolmen, a clerk, and a German shepherd. Between 1898 and 1911, their lock-up was in a separate building, behind this one.

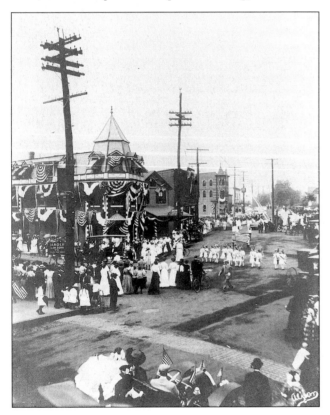

This scene of Ridgewood's first Independence Day Parade (1910) shows the celebrants marching east on Ridgewood Avenue across the railroad tracks and turning right onto Broad Street. In the left center of the photograph, decorated with bunting, is the Zabriskie Building, which was rebuilt as the Moore Building.

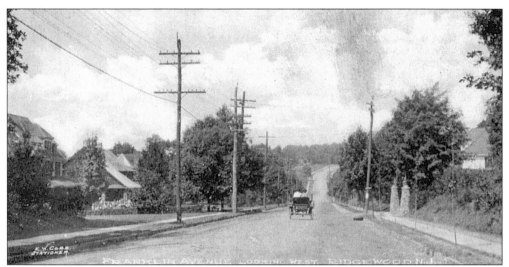

West Ridgewood Avenue (looking west) in this 1908 photograph depicts a street of limited development. The twin stone columns mark the entrance to Heights Road, while farther down the road, where the hill begins, is where West Side Presbyterian Church and Monroe Street are now located. At this time, more people lived east of the railroad tracks than west of them. Some of the choicest residential real estate was along Prospect Street, south of Hudson Street.

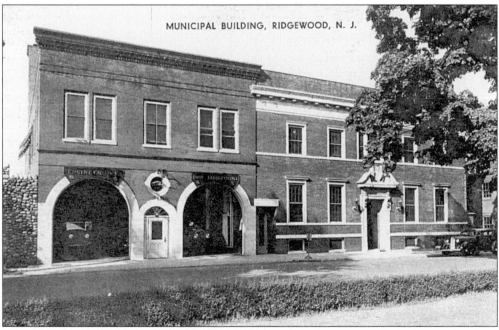

The year 1911 marked both the beginning of a commission government for Ridgewood and the completion of this municipal building on Hudson Street near Prospect Street. The fire and police departments occupied the first floor, while the second floor provided accommodations for village officials and a meeting room for weekly commission sessions. Lack of space resulted in the municipal offices relocating to 38 Oak Street in 1943. After the fire department moved to its East Glen Avenue site in 1992, this building was razed.

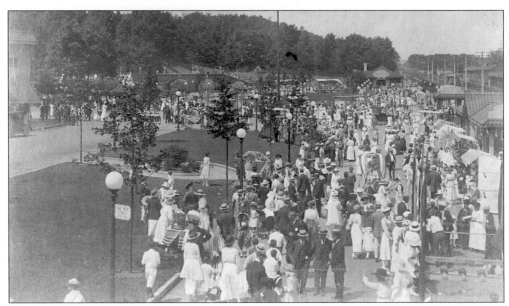

The 1918 Victory Bazaar, sponsored by the American Red Cross to benefit World War I soldiers, was a major event that involved thousands of people. Women in their summer finery and men in suits and straw hats promenaded past volunteers in booths selling their wares or offering games of amusement. A since-demolished, pedestrian overpass (left center), above Franklin Avenue, led to the future site of Pease Library.

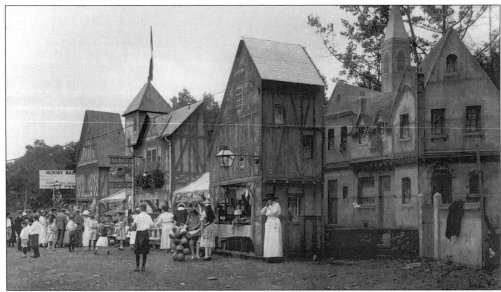

The artistic triumph of the bazaar was this re-creation of a French village on the west plaza of Garber Square, where food, drinks, and merchandise could be purchased. Today this artistic tradition continues each June when parents of high school graduates transform the gymnasium at Benjamin Franklin Middle School into an impressive, thematic setting for their children to celebrate graduation night.

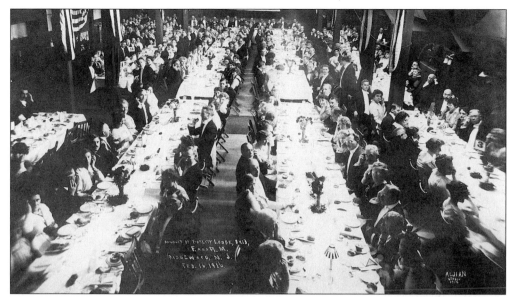

Begun in 1871, and thus Ridgewood's oldest organization, Fidelity Lodge 113 hosted a banquet for 450 persons in the top floor hall of the Wilsey Building on February 16, 1916. A highlight of the evening was an exchange of greetings with a similar gathering of Masons in San Francisco and Pasadena over the recently completed transcontinental telephone line of AT&T. Ridgewood thus had the honor of being the first small town to test this feat of modern engineering.

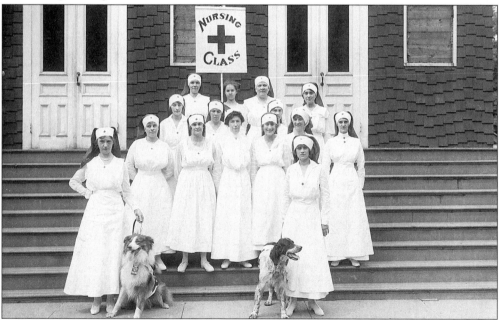

Members of the nursing class of the Ridgewood Chapter of the American Red Cross pose in front of the shuttered Opera House prior to duty overseas during World War I. By that time the Play House and Assembly Hall in the Wilsey Building had become preferred gathering places for large groups. The Red Cross not only provided clothing and accessories, but also steamer rugs and life-preserver body suits for crossing the submarine-infested Atlantic.

Edith S. Buck (1876–1954), great niece of Benjamin F. Robinson, was one of Ridgewood's first librarians and one of the first young businesswomen to commute to New York City, where she worked for a brokerage firm. During 1912-18, she did canteen work for the YMCA in England and France. She then moved to San Francisco where she owned the Metaphysical Library and Book Shop.

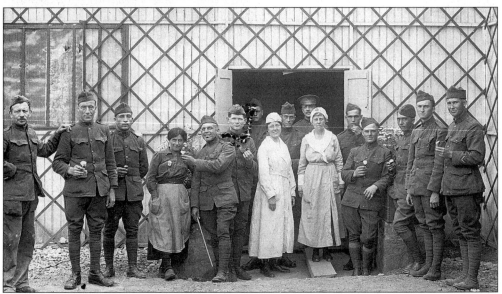

Edith Buck, (left center) in white, stands in the doorway of the YMCA "hut" in France. The soldiers hold poppies, immortalized by British officer John McCrae's poem, "In Flanders Fields," as the symbol of the soldier's sacrifice for this country. As noted on the World War I Memorial plaque in Van Neste Park, more young men from Ridgewood lost their lives in that war than in either the Korean or Vietnam wars.

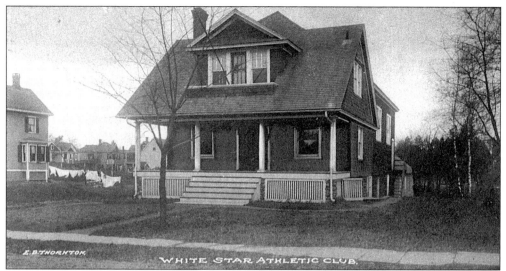

Organized in 1898 and incorporated in 1901, the White Star Athletic Club specified itself as "an association of less than five hundred members associated for the encouragement and practice of indoor and outdoor athletics." Soon thereafter it acquired property on South Maple Avenue and opened this clubhouse in 1904. The White Stars sold their athletic field on Ridgewood Avenue to the village in 1913, as part of the site for the new high school.

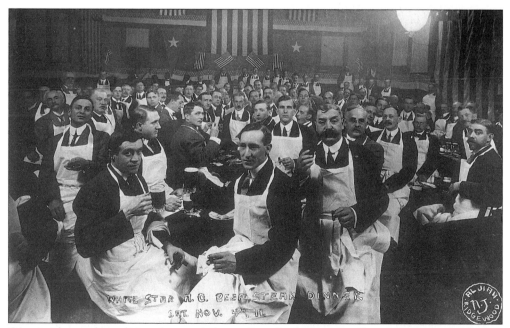

One timeless male tradition that carried over from the 19th and well into the 20th century was the beefsteak dinner. It was an annual event that drew virtually all the members of the White Stars Athletic Club to enjoy steak, beer, cigars, and each other's company. This dinner on November 4, 1911, in its patriotic setting marked their last major event as White Stars, for in 1912 they changed the name to the Town Club of Ridgewood.

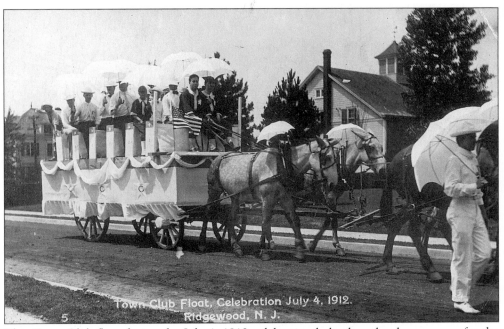

This Town Club float during the July 4, 1912 celebration helped mark a banner year for the organization. That winter it had purchased 12 acres on North Maple Avenue from the Ridgewood Golf Club. Its new clubhouse, scene of many social and public functions, had just been the setting for its most prominent affair. On May 25, 1912, President Taft addressed the citizens from the club veranda, the first-time visit ever to Ridgewood by a U.S. President.

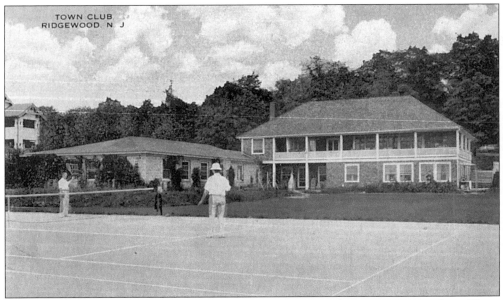

The Town Club grounds and clubhouse offered a wide range of activities for members. There were four bowling alleys, billiards and pool tables, whist and other card games, a library, dancing, baseball, and tennis. The club extended clubhouse privileges "to the ladies" and to family members, and tennis court privileges to all school teachers.

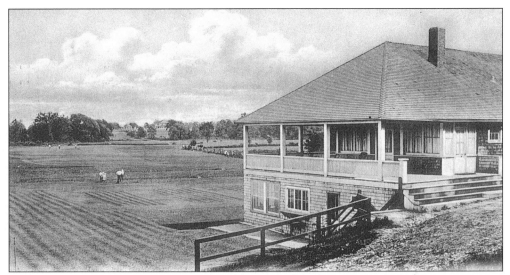

The Ho-Ho-Kus Golf Club, organized in 1893, was one of the first in the country. In 1899, it obtained 12 acres of property for a golf course on North Maple Avenue (adjacent to present-day Village Hall). Renamed the Ridgewood Golf Club in 1901, and then the Ridgewood Country Club in 1910, its clubhouse hosted numerous activities and social events. The organization remained at this location until 1913, when it sold the property to the Town Club.

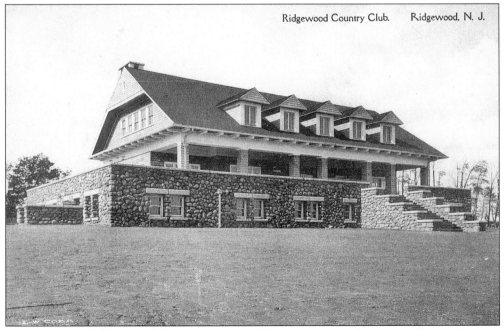

The Country Club's second home was 102 acres on Mountain Avenue, with a golf course cascading down to Lincoln Avenue that was a favorite place for tobogganing and "coasting" in winter. Two small lakes, stretching across most of the width of the property at the lower end, were golf hazards in summer and "ice parks" for skaters in winter. This clubhouse had a café and restaurant, bowling alleys, billiard and pool tables, and a dance pavilion.

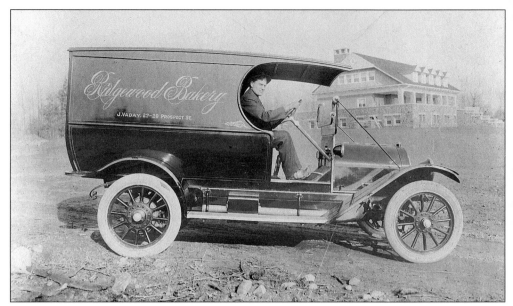

Stopping by the Ridgewood Country Club on Mountain Avenue (*c.* 1920s), this delivery truck from J. Vaday's Ridgewood Bakery on Prospect Street reminds us of another facet of how life once existed. Before there were supermarkets and extensive reliance on personal automobile use for shopping, local merchants delivered their products to homes, and peddlers of all sorts roamed residential streets selling a wide variety of goods and services.

When its clubhouse burned down in 1929, members decided to move to a less congested area. They purchased property off Midland Avenue in Paramus and built this facility. Its restaurant and banquet facilities remain in high demand. The Ridgewood Country Club has been host to such prominent golf tournaments as the Ryder Cup Championship (1935), the U.S. Amateur (1975), Coca Cola Classic (1981), and the PGA Senior Open (1990).

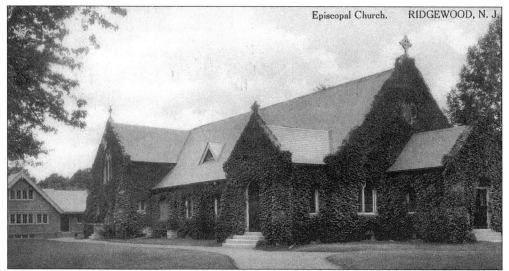

In 1866, Christ Episcopal Church held its first services in its church, a wooden structure, on the west side of Van Dien Avenue, which was moved in 1873 across the field to the present site at Cottage Place and Franklin Avenue. By 1895, it was inadequate for the demands of a growing parish, and a movement began to secure a new edifice, which led to the construction of this stone church and frame parish house in 1900.

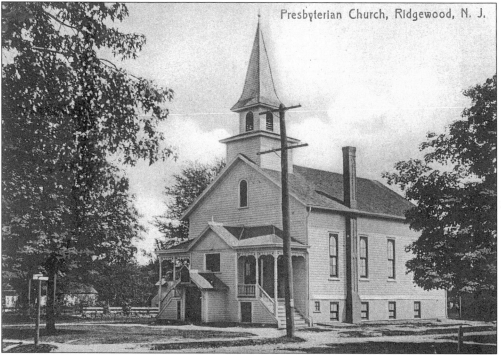

Presbyterian Church, Ridgewood, N. J.

Built in 1858 for a Christian Reformed congregation, this white church on the corner of South Pleasant and East Ridgewood Avenues became a Presbyterian church in 1904, after the New Jersey Supreme Court upheld the right of the congregation to change their affiliation to a less strict denomination. When the church was destroyed by fire in 1918, the congregation built a new one on the corner of east Ridgewood and South Van Dien Avenues.

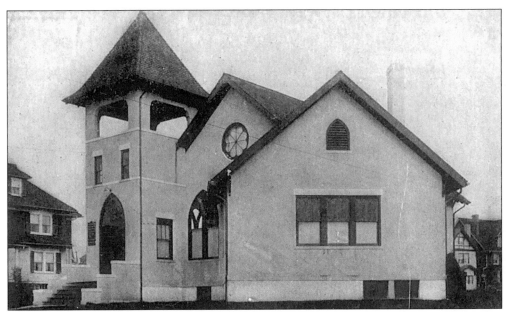

A concentration of German Lutherans, living in one of the earlier real estate developments on the west side (along Doremus and Ackerman Avenues from Godwin Avenue to Glen Rock), together with others living in other locales in the village, led to the creation of a church organization to foster their religious doctrines. Organized in 1907, the congregation erected Bethlehem Lutheran Church on Doremus Avenue in 1912-13.

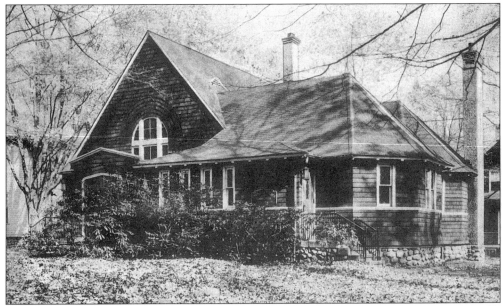

The Unitarian Society held its first religious service in 1895 in the Opera House, formally organized in 1896, and built this church on Cottage Place in 1900. A church auxiliary, the Woman's Alliance, set up in 1896 the first Woman's Exchange in Ridgewood and operated it successfully for two years. Under the direction of Rebecca W. Hawes, it paid out $1,200 annually to women who were in need of work.

While a student at New Brunswick Seminary, John Alfred Van Neste conducted services for the congregation of First Reformed Church, which first met at Shuart's Hall over Writenouer's grocery store at the corner of Broad Street and East Ridgewood Avenue. After his ordination, Rev. Van Neste became the founder and first pastor of the church, remaining until 1917, then continuing as pastor emeritus until his death in 1924.

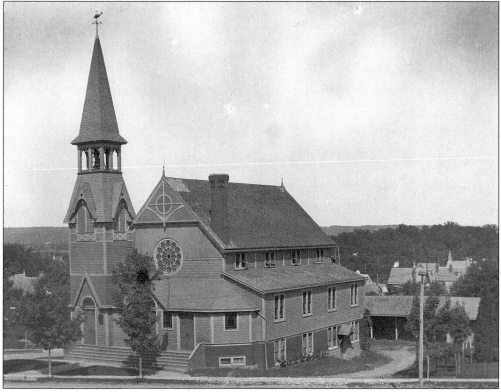

The First Reformed Church of Ridgewood, built in 1877, stood at the intersection of Dayton and Union Streets for 82 years. Congregational congeniality led to Baptists and Methodists finding a home there until they were able to build their own churches. Moreover, Rev. John A. Van Neste and his congregation played important roles in helping organize the A.M.E. Zion Church in 1882, then the West Side Presbyterian, Upper Ridgewood, and Glen Rock Community Churches.

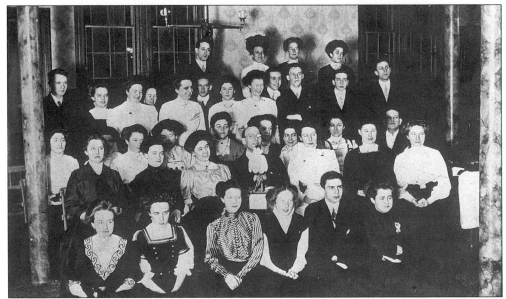

Gathering in 1907 at a Christian Endeavor party are members of First Reformed Church to honor Van Lieu Wyckoff, superintendent of the Sunday School (second row center), and his wife (seated at his left). Daughter of the publisher of the Ridgewood *Herald,* Helen Brainard Smith's (seated, third row center) recollections about Ridgewood in the early 20th century are extensively quoted in *The History of a Village* (1964).

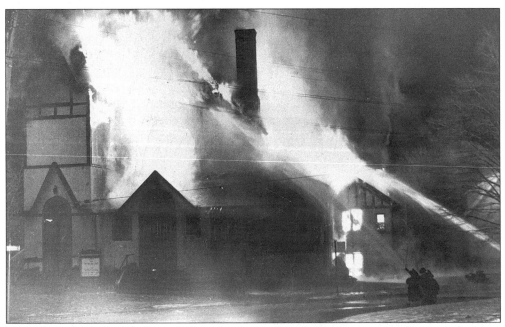

In the late 1950s, First Reformed Church prospered, and the congregation began preliminary plans for expansion. Those plans came to a dramatic halt in the early morning hours of January 21, 1959, when a blazing inferno ravaged the church building, despite the efforts of firefighters from Ridgewood and six other towns. The complete devastation prompted church leaders to consider relocating the replacement structure elsewhere.

A day after the fire, workmen maneuver a crane and wrecking ball near the collapsed steeple before razing what remained of the church structure. With support from churches they had once helped launch and their own determination, the congregation built a new church at 303 Prospect Street. In 1973, the former church site became the locale of the Van Neste Medical Arts Center.

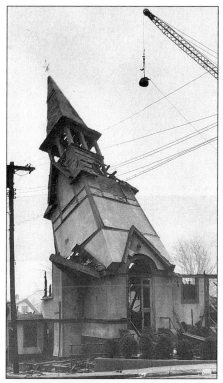

The A.M.E. Zion Church came into existence in 1882. Rev. John A. Van Neste of First Reformed Church gave considerable assistance in helping to organize the church, which held its services in the basement of Christ Church until its own building was completed on Broad Street and Highwood Avenue in 1900.

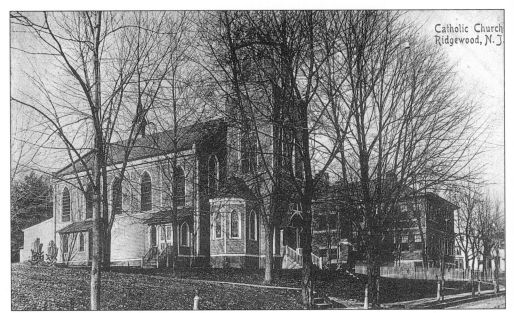

Constructed by the Union Street School in 1890, Our Lady of Mount Carmel Catholic Church had Rev. Michael Nevins as its first resident pastor. Joseph Carrigan donated the house next door, which served as a rectory until after completion of a new church on Prospect Street in 1915.

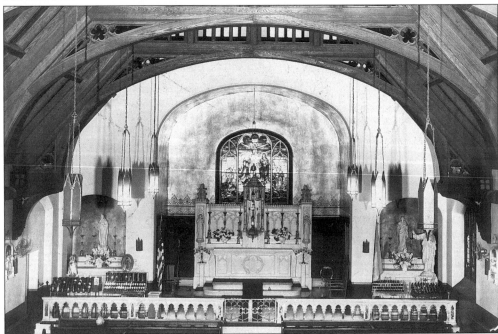

The serene interior of the new Our Lady of Mount Carmel Catholic Church had massive wooden beams and arches in a gothic style. Its seating capacity of 400 became woefully inadequate for a congregation of 7,300 parishioners by 1964, despite seven Sunday Masses and additional Masses in the Mount Carmel School. That year the church building was razed and a larger one built on the same site at Prospect and Hudson Streets.

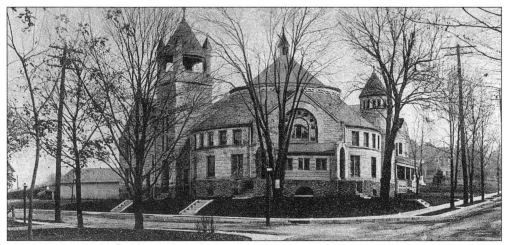

Organized as the Methodist Episcopal Church in 1895, the congregation remodeled the first floor of the vacated, wooden Union Street School and held services there until they build their own church. This tabernacle-style, gray-stone church—opposite the south end of Van Neste Square—was dedicated in 1903. Services were held here until 1964, when a larger church replaced it for the now United Methodist Church of Ridgewood.

Founded in 1905 with a membership of 15 persons, Mount Bethel Baptist Church—like several other early churches in the village—first met in unused commercial space until it could raise funds for its own building. In 1907, the congregation purchased a lot on Ackerman Avenue and built their first church. By 1916, their number had grown to 200, and, in 1941, the church moved to this brick edifice at South Broad and Dean Streets.

Originally called West Side Collegiate Presbyterian Church and initially sharing a pastor with First Presbyterian Church, the congregation dedicated this church on Monroe Street and West Ridgewood Avenue in 1913, then added two wings in 1915. This new church evolved from a need for a bible school for the west side children practically prohibited from attending bible school elsewhere, because of the dangerous railroad grade crossing.

Organized in 1920 with 46 charter members and the Rev. John A. Terhune as its first minister, the Upper Ridgewood Community Church built its first church in 1923. When a new sanctuary at the corner of Fairmount Road and Hillcrest Avenue was dedicated in 1965, this building was converted into a parish house with room for Sunday school classes and church offices.

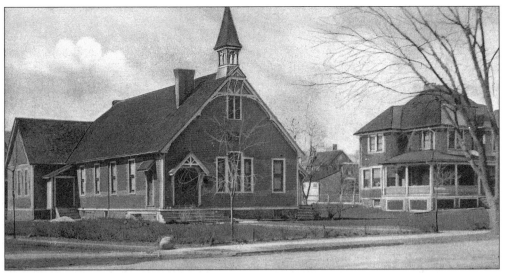

Built by P.G. Zabriskie for $3,028, the first church building of Emmanuel Baptist Church, at Hope Street and East Ridgewood Avenue, was dedicated on November 13, 1892. A small annex was added in 1897, then the second building, a "Decorated English Gothic" structure of stone, replaced the original chapel in 1912. The parsonage next door was built in 1900 and still stands.

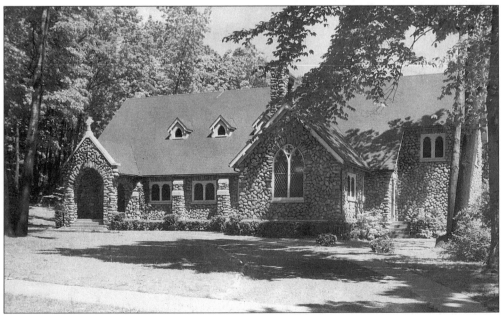

St. Elizabeth's Episcopal Church, located at 169 Fairmount Road, was started in 1923 by members of St. Bartolomew's in Ho-Ho-Kus, which itself was a branch of the village's Christ Church. This 1956 photograph shows the church before the building of its tower and enlargement of its nave, as well as the extension of its parish house and connection to the church, all done under the leadership of Rev. Alexander M. Rodger.

The Ridgewood Woman's Club posed for a picture before leaving for Atlantic City to attend the 1914 convention of the New Jersey State Federation of Woman's Clubs. The Ridgewood club, founded in 1909 by Fannie Caldwell Allen (center), was an outgrowth of an informal group called the Topics Club. The new organization directed the activities of its membership toward civic and social reform.

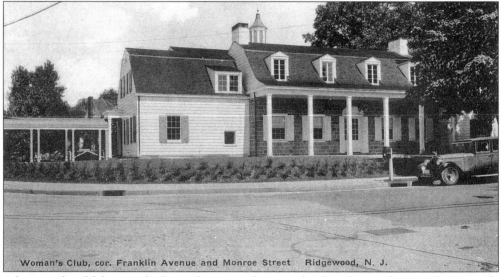

Woman's Club, cor. Franklin Avenue and Monroe Street Ridgewood, N. J.

After months of debating whether to locate on the more developed east side or on the west side of town, the Woman's Club of Ridgewood opted for the corner of Monroe Street and Franklin Avenue. Enhancing the clubhouse's exterior style of an old Bergen County homestead with its weathered sandstone front and gable roof, were many treasures from the Dutch Colonial Tolles House, then being dismantled for the widening of Franklin Avenue, now called West Ridgewood Avenue.

104

Jack and Kay Edson founded the Ridgewood Gilbert and Sullivan Opera Company in 1937. Opening night was on Thanksgiving with a performance of "Iolanthe," to mark the 55th anniversary of its premiere in England on November 25, 1882. This production at George Washington Junior High School drew a rave review in the *Bergen Evening Record*, and the group has performed shows every fall and spring ever since.

Most of the cast of the 1941 production of "The Mikado" pose on the stage at Glen Rock Junior High School. This was the first year of performances at this new locale, necessitated because previous productions were playing to sold-out houses and the group needed a bigger auditorium. The Ridgewood G & S Opera Company continues to offer free tickets to young Ridgewood students and takes its shows "on the road" to other towns.

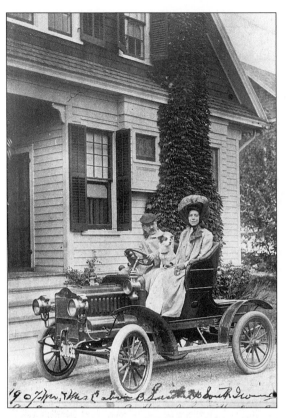

Before Henry Ford's assembly line brought a "Tin Lizzie" into everyone's financial reach, the ownership of a motorcar was a definitive status symbol of affluence. In this 1907 photograph, Mr. and Mrs. Calvin B. Smith of 240 South Irving Street, dressed in their touring clothes, pose proudly with their dog before heading out on a Sunday drive into the country in their roadster. The crank handle starter is visible in the front of the car.

Perplexed at finding two small cars parked in a single space, with the driver of the first car putting five¢ in the meter for an hour, Ptl. Anthony Dinice in 1958 asked his superior officer for advice. Lt. William Babcock said, "One car belongs in one space," and had the car in the rear ticketed for improper parking. Across the street are such once-familiar stores as Stevens, Normandie, Ridgewood Drug Co., and Winchell's. Greenery Flower Shop is still there.

All seats were reserved for the grand opening of the Warner Theatre in Ridgewood in 1932. The movie, which featured Warren Williams in *The Dark Horse*, was followed by personal appearances of show business luminaries, including child star Mitzi Green, who did an imitation of George Arliss. Master of Ceremonies Jack Haley read a congratulatory "telegraph" from Hollywood's three Warner brothers, whose portraits graced the ticket shown here.

This authentic old milk wagon in the 1963 Independence Day parade helped evoke memories of many years ago. The entry was appropriately sponsored by the Junior Woman's Club of Ridgewood, which supported the milk fund as its main project. By the 1920s, the milk wagons gave way to distinctive milk trucks, almost all of which have also disappeared.

Leonard Taft founded the Ridgewood *Herald c.* 1900, and then Brainard G. Smith became its editor and publisher in 1905. This staunchly Republican newspaper with the motto "You can't do too much for Ridgewood," moved in 1912 to a modern printing plant here at Hudson and Broad Streets. Smith's daughter Helen and son Bevier remained part of the staff after the paper merged with the *Ridgewood News* in 1941 and became the *Herald News.*

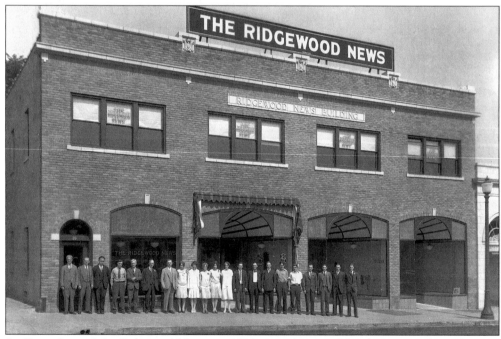

Staff members of the *Ridgewood News,* in 1929, pose for noted local photographer Aljian in front of their new building. As the paper grew, it took over all of the ground floor, converting the middle and far right doorways into windows only. In 1955, when their space needs changed, they moved into the old post office next door. Café Winberie now occupies the first floor.

John B. Hopper, one of four generations of his family to be town veterinarian, served as fire chief (1910–1912) and twice as mayor (1919–1923, 1927–1931). Part of his civic legacy was the creation of a Planning and Park Commission to survey and plan the town's future development, including a system of parks, extension and widening of streets, and location of public buildings. He also played a role in securing the land to build Valley Hospital.

This version of Valley Hospital, fronting on Linwood Avenue, opened in 1951 and had 108 beds, 22 bassinets for newborns, and 87 staff doctors. At the far left is the old Steilen house, renamed Kurth Cottage and used by the Woman's Auxiliary of Valley Hospital as a hospitality shop and luncheon, tea, and snack facility. Both structures are gone now, replaced by a new hospital complex with 421 beds, 43 bassinets, and over 500 staff doctors.

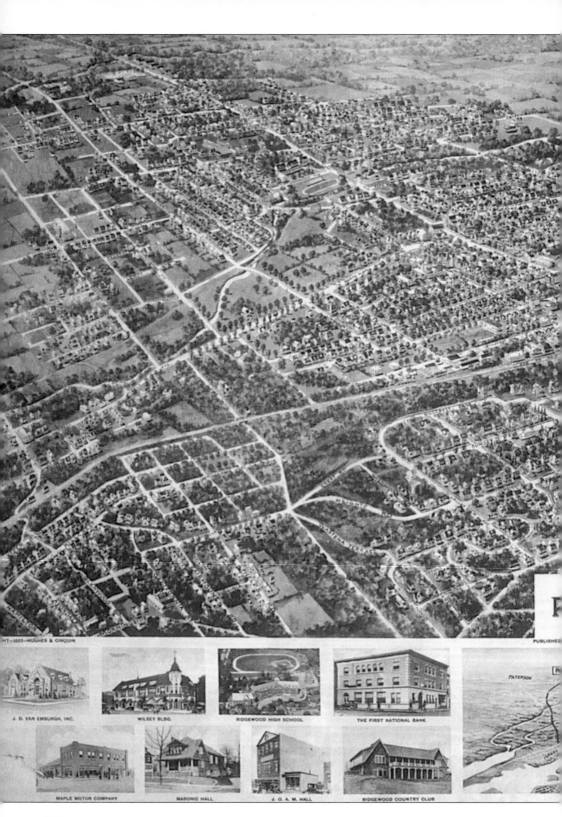

J. D. VAN EMBURGH, INC.

WILSEY BLDG.

RIDGEWOOD HIGH SCHOOL

THE FIRST NATIONAL BANK

MAPLE MOTOR COMPANY

MASONIC HALL

J. O. A. M. HALL

RIDGEWOOD COUNTRY CLUB

110

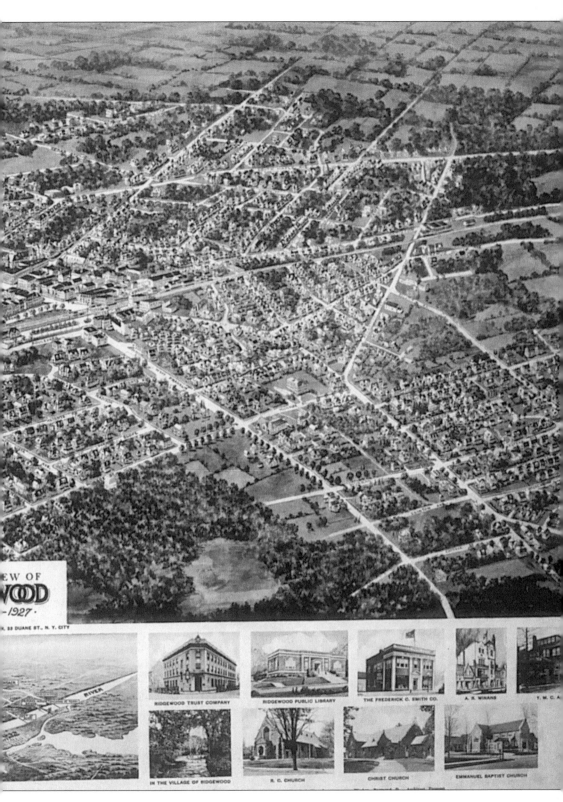

EW OF
WOOD
·-1927·

N, 33 DUANE ST., N. Y. CITY

RIDGEWOOD TRUST COMPANY

RIDGEWOOD PUBLIC LIBRARY

THE FREDERICK C. SMITH CO.

A. R. WINANS

Y. M. C. A.

IN THE VILLAGE OF RIDGEWOOD

R. C. CHURCH

CHRIST CHURCH

EMMANUEL BAPTIST CHURCH

Graydon Pool was the realization of a dream by Samuel Graydon, the first head of the Shade Tree Commission, who donated 6.6 acres of grazing land in 1927. He originally envisioned a larger swimming area than the 2.7-acre natural lake, but village officials thought it too costly. The pool opened in 1929, with badges at 50¢ for adults and 25¢ for children. A staff of one provided all services, from lifeguard to maintenance.

In 1975, Andrew M. Lester still worked the 12.3-acre farm, as his family had done for generations. A 1960 proposal to condemn his property for the expansion of adjacent Graydon Park prompted many fair-minded citizens to defend his rights vigorously, and the proposal was quickly dropped. Mr. Lester stipulated in his will that the property be offered to the village at a reasonable price.

The Lester Stable was built in 1870. A fine example of a late-Victorian stable, it was moved to its present location at 259 Maple Avenue, in 1981, on land sloping back from the avenue, and raised on supports to give it a new basement level. Originally owned by the Mastin and then the Lester families, it has a cruciform plan and is cross-gabled, with a double, cross-braced stable door with an elliptically arched top, flanked by circular windows.

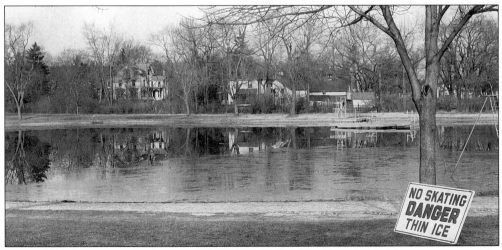

This 1954 winter photograph of Graydon Pool, looking north from Linwood Avenue, shows the Lester property in the background. Mr. Lester's house is on the left and to the right is the stable, which was moved from that location to a site in front of the house, after it was destroyed by fire in 1977. Now Maple Park, it contains a trail marking various plants and trees, as well as ferns planted by the Girl Scouts.

This Colonial Revival/Princess Anne house, located at 138 Prospect Street, was built by Joseph T. Christopher in 1890. Daniel La Fetra was president of the Ridgewood Board of Education when the Beech Street School was constructed. He is credited with introducing the idea of a graded school system as state law. The house originally had a wraparound porch with paired Tuscan columns, a cobblestone foundation, Palladian windows in gable ends, and a vestigial octagonal tower at north facade angle.

In 1973, the Junior League of Bergen County converted the large old house on Prospect Street into the county's first group foster home for girls. Here, two Ridgewood members of the Junior League—Judy Moody and Barbara Bolger—help clean the home, which was reconfigured to house eight girls, ages 12-18, with foster parents. Woodlea Group Home continues its community service today.

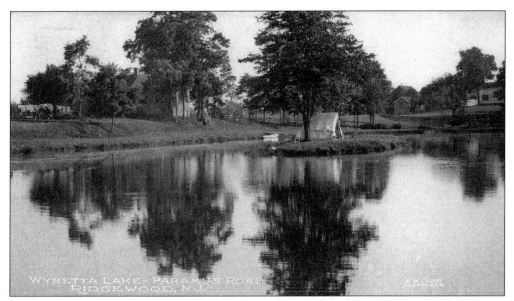

Wynetta Lake on the east side of Paramus Road (between Linwood and Ridgewood Avenues) was a pleasant place for swimming, boating, and fishing during the late 19th century, as well as during the first several decades of the 20th century. Numerous out-of-state visitors found this postcard scene of the lake a favorite one to send to their families or friends.

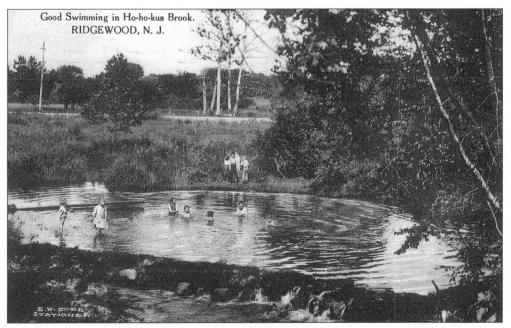

This scene from the past captures a familiar piece of Americana, the old swimming hole. Many communities boasted of such a place in the 19th and early 20th centuries, and Ridgewood was no exception. This 1929 postcard photograph reads "Good Swimming in Ho-ho-kus Brook, Ridgewood, N.J." The dammed brook, with Ridgewood Avenue in the background, was a favorite spot for young people on a hot summer day.

The Cameron Carriage House, located at 12 East Glen Avenue, was built in the 1850s. This is a fine example of a sturdy, mid-19th-century carriage house, set on a stone foundation with stone and brick walls. The original disposition has only been slightly modified on both the exterior and interior. The original beams remain, as does one of the four stalls once placed in the western half of the building.

Since 1947, the structure has been home to the Ridgewood Art Association, which adapted it to present-day use as a studio and exhibition space. In this 1951 photograph, Peggy Dodds demonstrates some painting techniques to members of the association. Across the street from the Art Barn, as residents now call it, is the Alpin J. Cameron stone house, which, together with this old carriage house, gives a picture of one of Ridgewood's large 19th-century estates.

Seven

THE "LOST" BUILDINGS

Although the village of Ridgewood is fortunate to have many older commercial and residential buildings of architectural and/or historical significance, it has also lost others. Some are still-standing structures but have been so extensively altered that little of their original fabric remains and they do not qualify for listing on the National or State Registers of Historic Places. Others have been torn down, either to make way for new construction or because they were in such a state of deterioration that they were beyond salvage.

Often the "lost" buildings have been residences that yielded to an expanding commercial center. Much of this change was a natural progression, as population growth spurred land development on previously wooded tracts or farmland, in turn increasing demand for local goods and services. Also, as Ridgewood grew in size, previously adequate churches and schools became too small, necessitating erection of a larger facility and the demise of the smaller one.

In many cases the new buildings—whether church, commercial, educational, or residential—were a definite improvement over what they replaced. In some cases the destruction of these buildings caused the loss of a real treasure in the village's inventory of buildings that were an aesthetic and important part of the past. In still other cases, the extinction of some buildings was an inevitable event as their age, construction viability, and usefulness rendered them obsolete.

In the pages that follow, we offer examples of some of the Ridgewood buildings that are no more. These photographs provide a glimpse into what was once part of the community's past, both in its physical appearance and in its lifestyle.

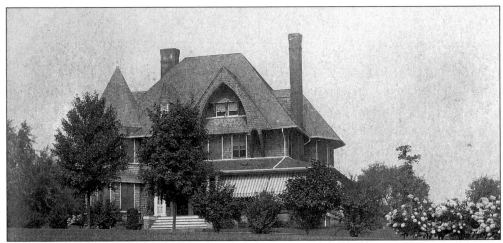

Built *c.* 1900, the Fullerton-Kraft House was located on Godwin Avenue. Formerly the residence of W.J. Fullerton, president of Citizens National Bank, this gracious and charming place became the home of Henry and Katherine Kraft in 1927. When its new owner, West Side Presbyterian Church, was not permitted to establish a Senior Citizens Center in the house, citizens of Ridgewood bought the property, destroyed the house, and deeded the 5 acres to the town as Citizens Park.

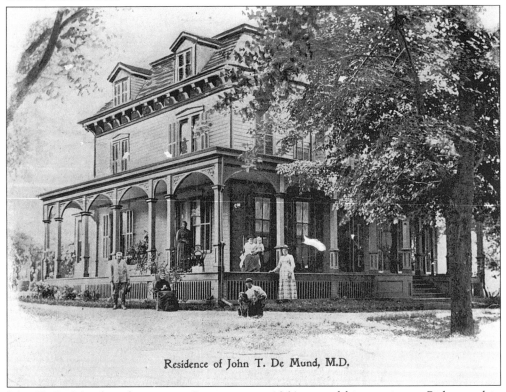

Residence of John T. De Mund, M.D.

John T. De Mund, a physician in Paramus since 1864, moved his practice to Ridgewood in 1878, thereby becoming the town's first physician. He and his family lived in this comfortable Victorian-style home on Oak Street, at that time all residential, near the site where the World War I Memorial now rises in Van Neste Square.

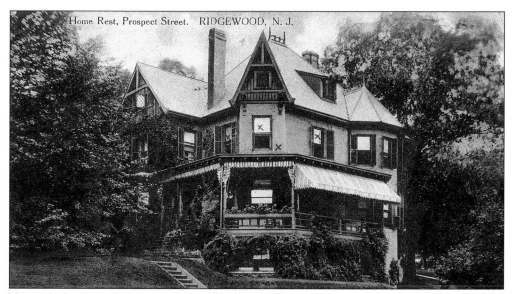

Home Rest, Prospect Street. RIDGEWOOD, N. J.

Now, 181 Prospect Street is considerably altered. "Home Rest," a Gothic Revival, was built in 1897 by Maurice Fornachon (1841–1914). He was a prominent architect who lived in Ridgewood from 1876 to 1910, and who designed residences and office buildings in New York City from 1869 to 1900. The steeply hipped roof, with a cresting of arched railing and finials, gave the house the intended "chateau" design.

This attractive landmark, the Warren Allabough house at 109 W. Ridgewood Avenue (adjacent to Heights Road), disappeared from the village scene in October 1971. Gutted by fire, the stately Victorian home was subsequently razed. After the corner lot stood vacant for several years, a developer built a more contemporary two-story house on the site.

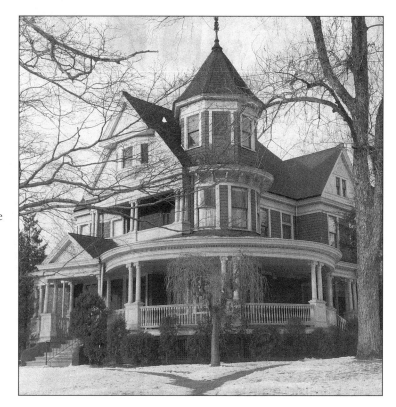

119

The Knothe Bungalow was built in 1897. Another dwelling built by Joseph T. Christopher, "The Bungalow" has a low hipped roof, eyelid dormers, front and side porches with posts, and a cobblestone foundation. Frank Knothe, a New York manufacturer, was secretary of the Orpheus (music) Club founded in 1909, and concerts were held on the grounds of this 152 Cottage Place home.

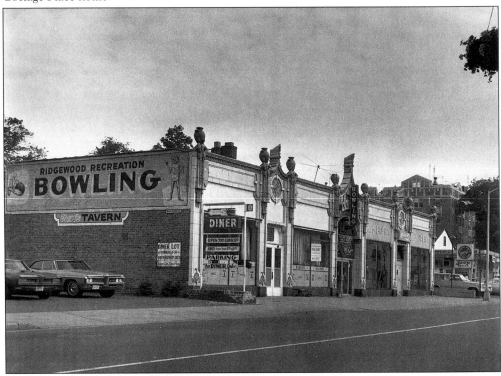

The Art Deco style of the Ridgewood bowling alley on North Maple Avenue near Ridgewood Avenue offered an excellent example of the taste for modernity between 1925 and 1940. Exotic caryatids hold large urns above their heads, the urns projecting above the flat roof line, as do the stylized achantus leaf finials, which top the peak of each entrance portal. The central portal is topped by an elaborate archway while the side portals have intricate oval windows above them.

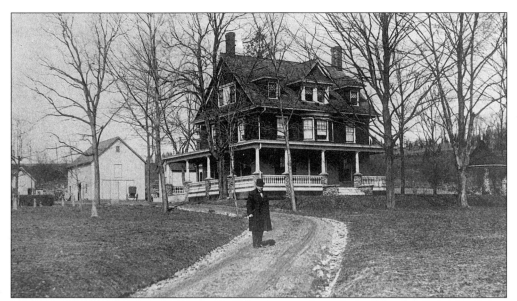

In this mid-1920s photograph, Everett L. Zabriskie stands in front of his house at the former location of his family's saw and grain mill. Over a century old, the building was demolished in the summer of 1962 to make way for new housing in the rapidly growing community.

Originally the home of Mr. and Mrs. Abraham Terhune, this 1870 structure was located on the northwest corner of Maple and Ridgewood Avenues where Sealfons now stands. Their son Harry, who had been a famous vaudeville magician, bought the building in 1890, and renamed it the Rouclere House, after his stage name. Now a prominent hotel, its guests included many celebrities, especially vaudevillians, including Harry Houdini.

In the late 19th and early 20th centuries, Ridgewood Avenue to the east of Oak Street was mostly residential. This Terhune residence stood at the corner of East Ridgewood Avenue and Cottage Place. In 1928, the YWCA moved to this locale from the old Opera House. A decade later, this house was torn down, replaced by the then-named Public Service building, which has recently been remodeled and is now home to Rite-Aid.

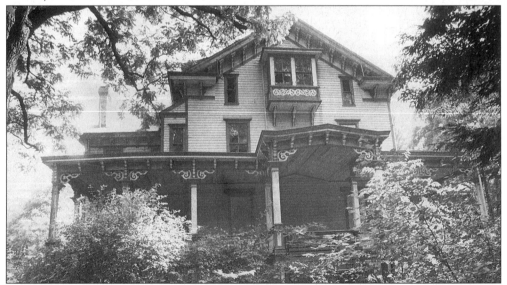

Lester's stately Victorian home and property became available to the village after his death in 1976. Opinions varied as to the best use of the building, but a devastating fire ended all possibilities. Salvaged was the stable, which was restored, relocated, and is now used by the Parks and Recreation Department. The renamed Maple Park is bounded by Graydon Park, North Maple Avenue, Meadowbrook Avenue, and Northern Parkway.

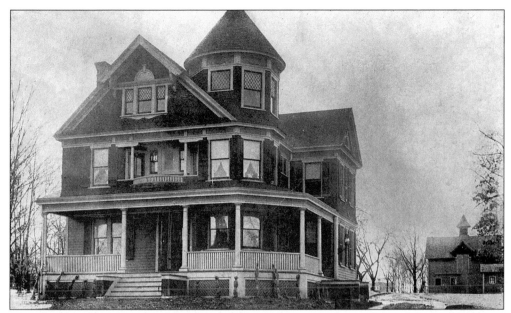

This photograph is the Original Frank H. White House, which is still located at 148 Prospect Street. Built by Joseph H. Christopher in 1890, it was here in 1891 that Clarence W. Shutts met with Frank White about establishing a Baptist church in Ridgewood. On July 15, eight persons attended their first "cottage prayer meeting" to plan the founding of Emmanuel Baptist Church. On October 4, with 47 in attendance, the Sunday school was organized, meeting in the new Billings barn on Brookside Avenue, with benches loaned by Mount Carmel Catholic Church.

The Frank H. White House was so extensively altered that its integrity was destroyed. Today the house is no longer recognizable from historic pictures. It was originally a Princess Anne, but its surface has been changed to a synthetic siding. Its tower, balcony, wraparound porch, and trim have been removed, a wing added, and a new porch and door installed.

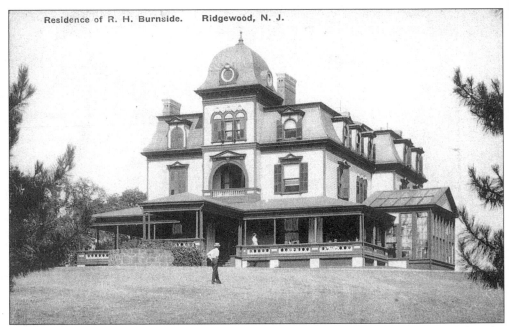

Residence of R. H. Burnside. Ridgewood, N. J.

Until 1952, this large home of Robert H. Burnside, and the huge barn behind it, added to the picturesque quality of North Maple Avenue. Mr. Burnside had for many years been the manager of the famed New York showplace, the Hippodrome, and crammed inside both structures was his valuable collection of theater memorabilia, which went to the New York Public Library after his death. Split-level ranch homes now occupy this site.

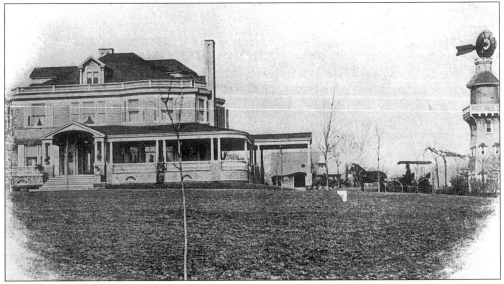

"Grassmede" was the name that Henry S. Patterson gave to his estate at 305 Godwin Avenue. In the 1950s the estate was considerably modernized and known then as the Sheffield residence. Its existence came to an end in 1962 when it was demolished to make way for the construction of a new edifice for the First Church of Christ, Scientist, whose congregation had outgrown their old building at the corner of West Ridgewood Avenue and Washington Place.

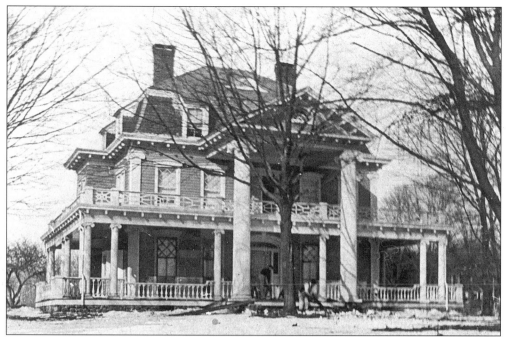

This house once belonged to the Kidder family. Frederick Kidder, the first to be married (to Jane Reed Dayton) in the Episcopal Church in 1868, donated a building site to the Reformed Church in 1877. William Kidder ran the Academy on North Van Dien Avenue, the most successful of all private schools. Then the site of the Ridgewood Secretarial School, this house was torn down in 1959 to make way for Kings Supermarket and the Village Shopping Center.

Another house that yielded to the expanding commercial district was this residence at the corner of Maple and Franklin Avenues. In this 1912 photograph, one can discern other large homes farther up Franklin Avenue and two women walking from uptown, perhaps on their way home, to visit a friend, or to meet others at the nearby Rouclere House. By mid-century a gas station was on this site, replaced by Brake-o-rama.

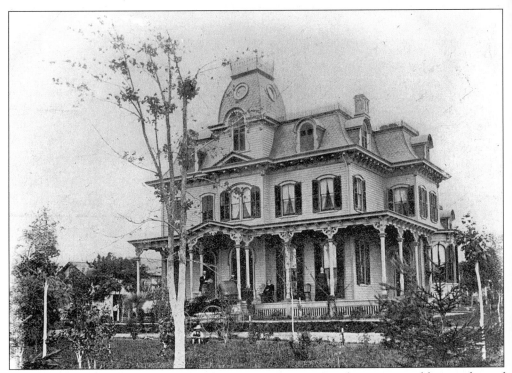

The post-Civil War home of Peter Ackerman on Paramus Road was occupied by members of the family until it was destroyed in 1965. Ackerman was the first president of the First National Bank in 1899. After a fire destroyed a storefront bank on the north side of Ridgewood Avenue near Chestnut Street that same year, the bank built its own edifice at Ridgewood Avenue and Prospect Street.

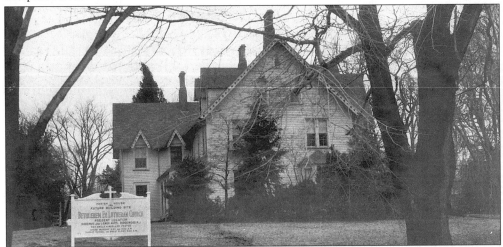

Samuel Graydon came from New York in 1853, when he obtained land from his father-in-law, Samuel Dayton, who had purchased it from the Van Emburgh estate. Graydon lived here in Concord Hall, a 27-room house on Linwood Avenue, and his rye fields extended from Cottage Place to Oak Street. In 1955, the Bethlehem Evangelical Lutheran Church bought the property and converted it for use as a Sunday school. In 1968, the mansion was razed for construction of a new church.

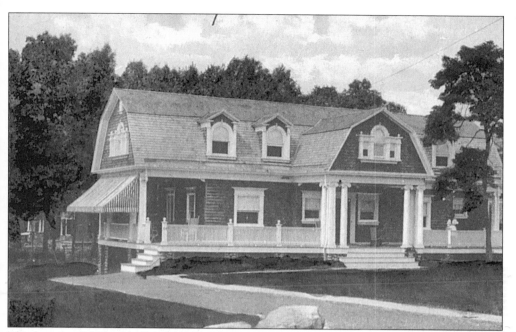

This house at 76 Heights Road (1904–1910), called "Aliquippa," was at the time included in a postcard series on fine homes in Ridgewood. A Dutch colonial revival with seven bays with gambrel roofs, it had gabled dormers with arched windows. Its porch had paired posts with a gambrel end above enclosing a prominent Palladian window. Despite protests by neighbors, the new owner demolished the house in late 1999, and replaced it with a new brick colonial.

Located in a then-residential area at the corner of Franklin Avenue and Cottage Place, this large house served as the home for several prominent Ridgewood families until 1939, when the YWCA purchased the building. The organization remained here until 1951, offering a variety of activities and courses for the young women of the community. Today this site is a parking lot for Grand Union.

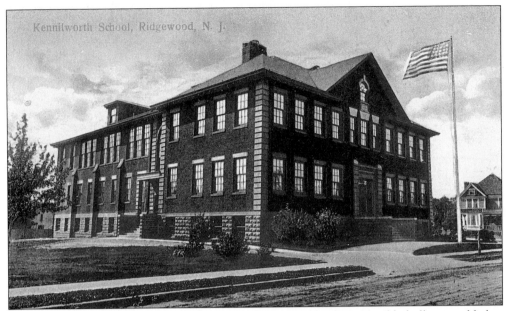

Originally a four-room building (1905), seven more rooms and an assembly hall were added to the Kenilworth School in 1911, to meet the needs of a growing population. When Somerville School opened in 1951, Kenilworth closed, only to reopen two years later as Somerville Annex for grades 5-6. When Hawes School opened in 1966, Kenilworth ceased to exist as a school but continued as an administrative facility. In 1980, it was demolished and the property sold for three one-family building lots.

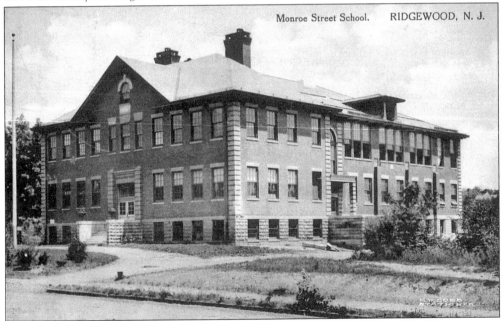

Also a four-room building, built in 1905, with additions constructed in 1911, the Monroe Street School was destroyed by fire in 1926, the same year that fire also consumed Willard School. Both schools reopened in new structures in 1927, but the Monroe Street School was rebuilt as a junior high school and renamed George Washington Junior High School.